ART NINJA

ART NINJA

Pen Designs

PHYLLIS P. MILLER

 ARCHWAY PUBLISHING

Archway Publishing books may be ordered through booksellers or by contacting:

Archway Publishing
1663 Liberty Drive
Bloomington, IN 47403
www.archwaypublishing.com
1 (888) 242-5904

ISBN: 978-1-4808-3457-6 (sc)
ISBN: 978-1-4808-3458-3 (e)

Library of Congress Control Number: 2016948051

Print information available on the last page.

Archway Publishing rev. date: 7/26/2016

To Sydney,
who is always thrilled with her grandmother's pen designs.

CONTENTS

INTRODUCTION

Are you a doodler? Do you cover your papers with simple drawings when you are bored? If you do, you are a doodler. I do not think many meetings or classes went by without my notes surrounded by drawings. I taught a fifth-grade student one year who doodled everywhere on her paper. She was a master doodler, and I praised her creativity. The girl grew academically and artistically that year. Her mother came in at the end of the school year and thanked me for understanding her daughter. My encouragement had made a difference in her life. She told me that previous teachers had always criticized her for doodling on her work.

I had another student who struggled with focusing. I allowed him to doodle his notes on topics I was teaching. "Mind mapping" is the more technical term. His retention of subject matter increased.

Simple pen drawings are one of the most basic forms of art. The process of making doodle marks can be relaxing and gratifying. Sometimes it is easier to sit through classes and listen while drawing. A person can still listen while doodling and feel more productive.

I remember as a teacher when a fellow professional told the staff at our school that children must not draw as you are reading to them, but must pay attention. I could never understand that. Most of the students who drew as I read tuned in to the story I was reading. I knew this was true because of their questions or participation in comprehension questions following the reading session. In order to work within the system, I gave twelve-by-eighteen-inch papers to the students and told them to use "mind mapping" with pictures, words, or both about the story as I read. Doodling is just part of some people: they are budding artists in the making.

Where do you go to find designs beyond what I have given you in this book? Look in your kitchen drawers, sewer covers on the road (preferably where there are not cars), brickwork on buildings, bubbles, sidewalks, iron fences, nature, shadows dancing across your wall, bacteria under a microscope, sand on the beach, fabric, baskets, waves, railroad tracks, drops of water on glass,

and other objects. The list could go on forever. Once you find designs to use, you just have to make some small variations to them, and you will have a completely new effect.

First, take a pencil and sketch in your design before committing it to ink. I like to use a ruler to mark straight lines, and I find round objects to trace if I need a round design. The worst thing you could do is get to the end stretch of a picture and make a mistake. Even then, you may be able to work the mistake into your design. I recommend that you practice designs first. Keep food and drink away from your workspace!

You will find that some patterns become your favorite ones, and you will use them repeatedly. Others you may seldom use. This type of art is easy to start with, since all you need is a paper and pen. A simple gel pen will do. I prefer an art pen, as it is both waterproof and permanent. It will not smear like some of the gel pens do. If you are right-handed, start your work in the top left-hand portion of your page; begin on the right side if you are left-handed. This is to prevent dragging your arm across your work and smudging your designs. Even the permanent ink may smear if touched right after drawing.

Join those of us who love to cover our papers with doodles. Be the best doodler you can be!

C H A P T E R 1

PEN DESIGNS

Designs are in the world all around you. Walk down the street in your city and see how many designs you can find. Recently, I visited downtown Salt Lake City, Utah. I used my camera phone and took pictures of all the designs I could find—patterns on the sidewalks, fences, brickwork, old buildings, metal covers, windows, flowers, and plants. In a matter of minutes, I had at least ten pictures of designs I could use in my pen drawings. Walk around your house, inside and out. See how quickly you can find at least ten patterns.

I started this booklet with thirty designs. I thought thirty would be a good number. I looked at the designs and realized I should do thirty more, since I had forgotten some of the best designs. This was not enough. I added thirty more designs, and before I could stop, I had made 120 designs!

The first exercise is to coax out the doodler deep inside of you. The second exercise is for practicing. Each pen design has an empty rectangular box next to it for practice. The pages that follow are master pages to use as a quick reference when deciding what designs to use. Notice how the patterns are lighter or darker. Some have circular patterns that fill in irregular shapes more easily. Then there are straight lines for rectangular and square shapes. Learn control and confidence in your strokes. Practice drawing steady, straight lines and circles.

Exercise #1: Starting Point with Name

Draw your name in bubble letters. Fill in the bubbles with anything that comes to mind. This is your starting point. After you have learned various pen designs, try your name more than once. Each one will be unique.

The example is my name. What did you come up with on your own? I strongly recommend using a light pencil mark to outline your name before committing to pen.

Variations: Instead of bubble letters, use box letters. Stretch the letters out wide. Stretch the letters tall.

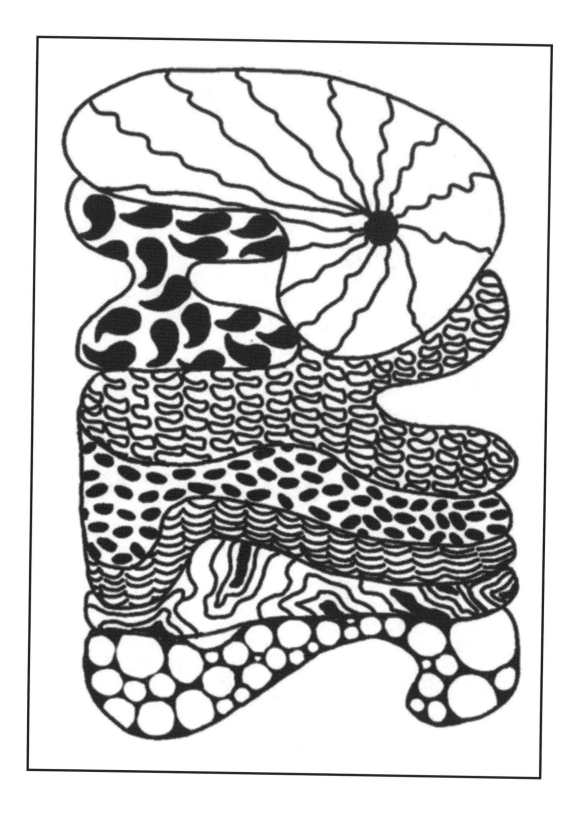

Exercise #2: Pen Design Practice Sheets

Copy the worksheet papers, and practice the designs. Find which ones are best for you.

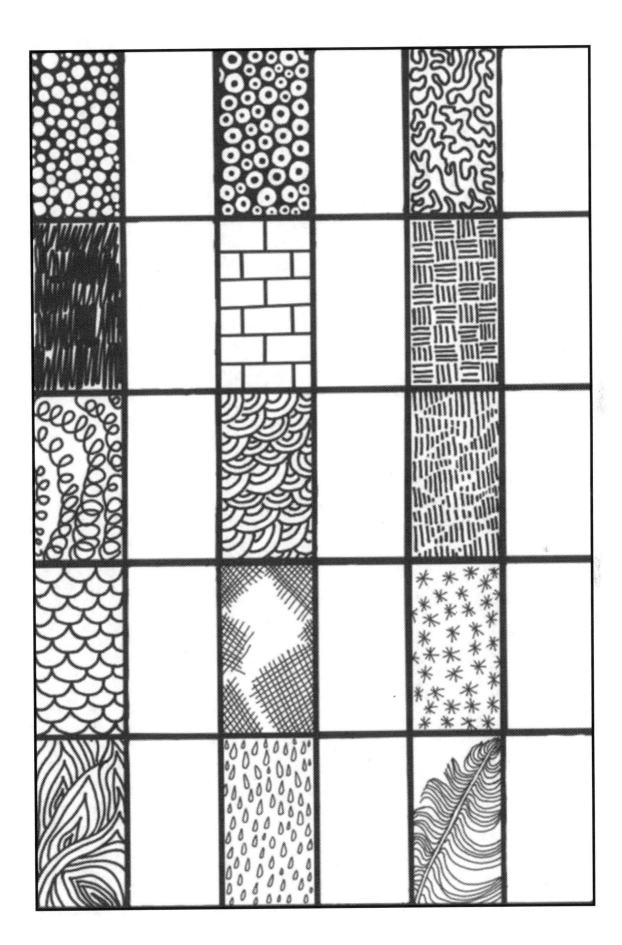

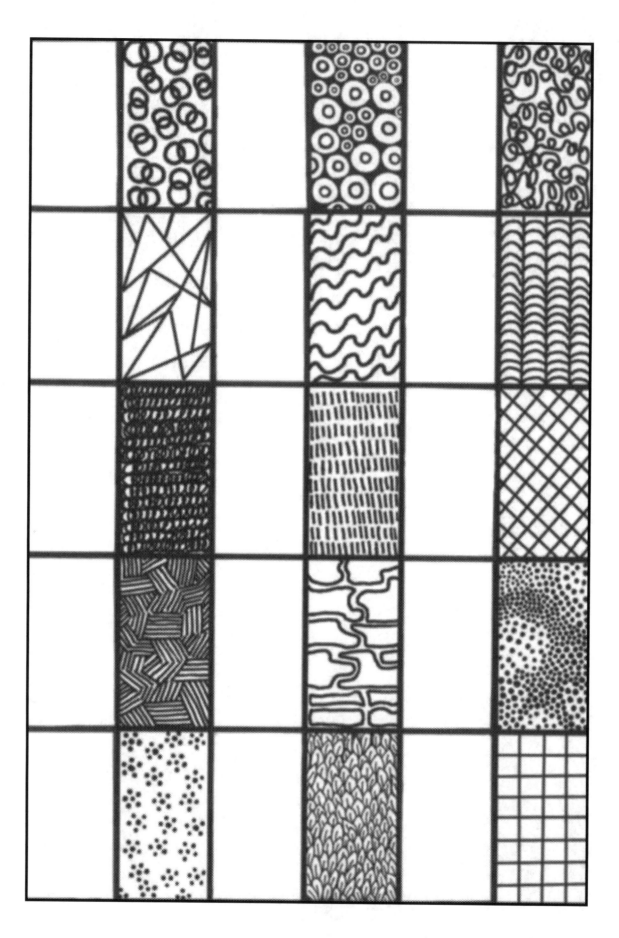

4

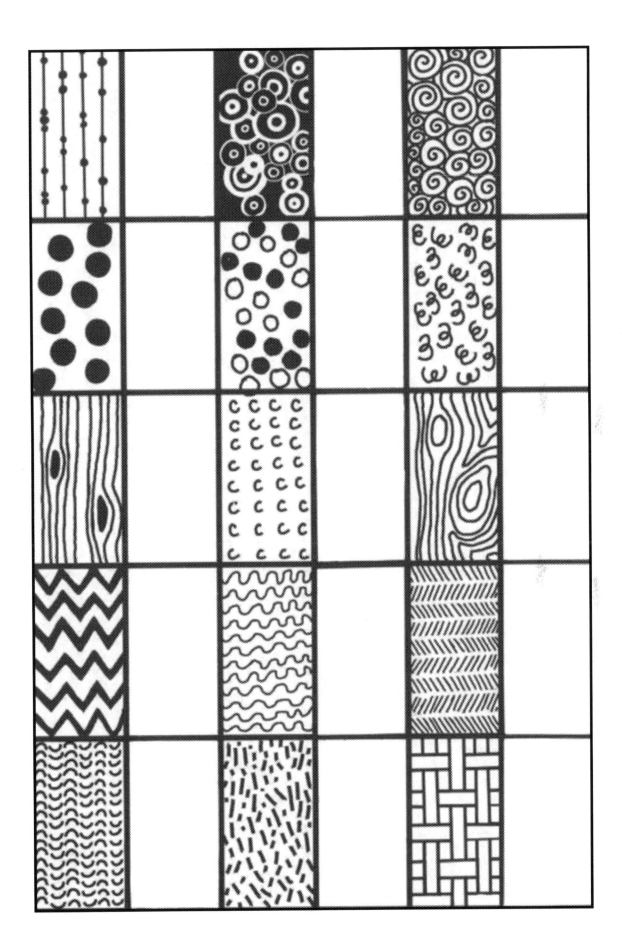

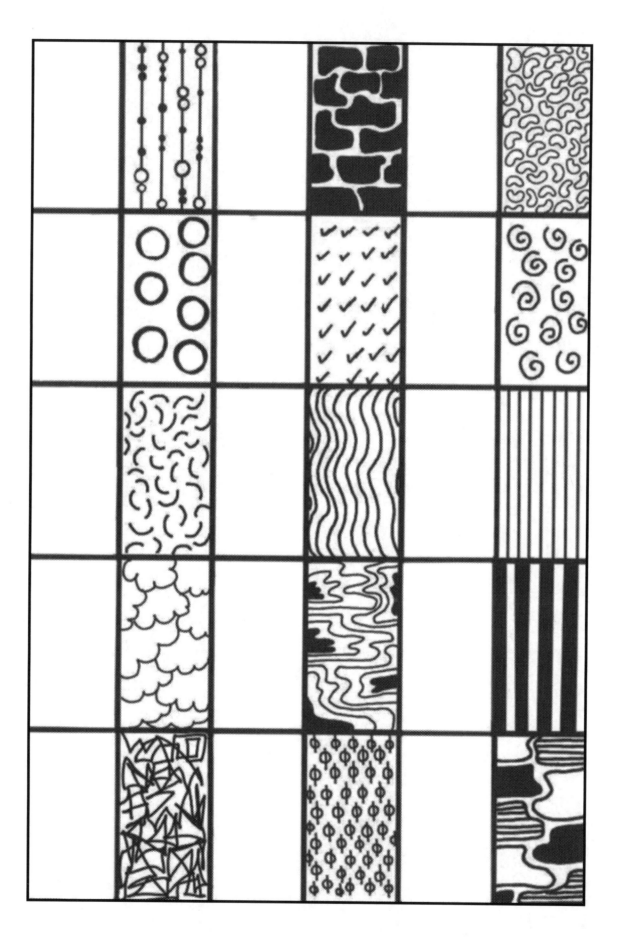

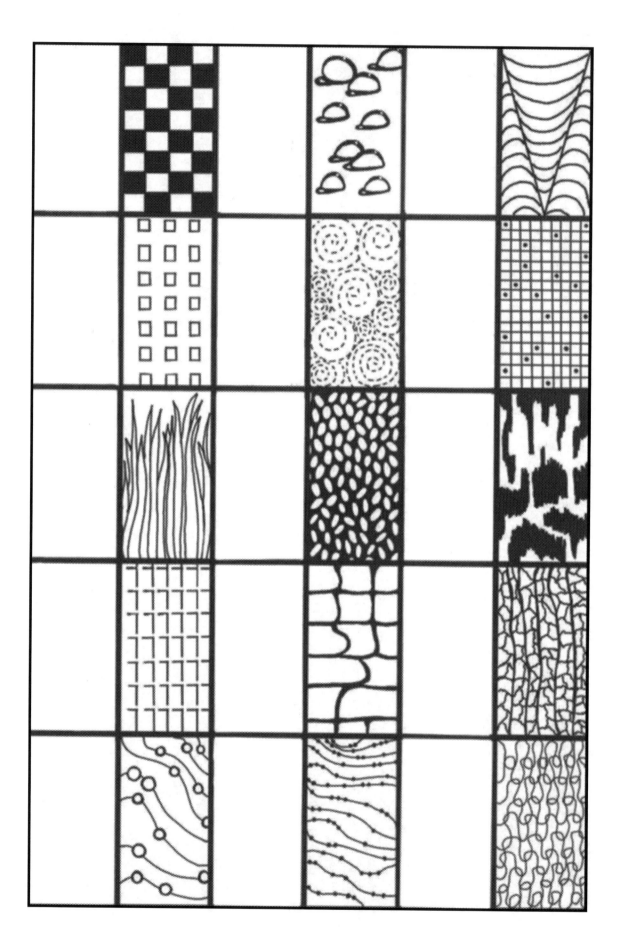

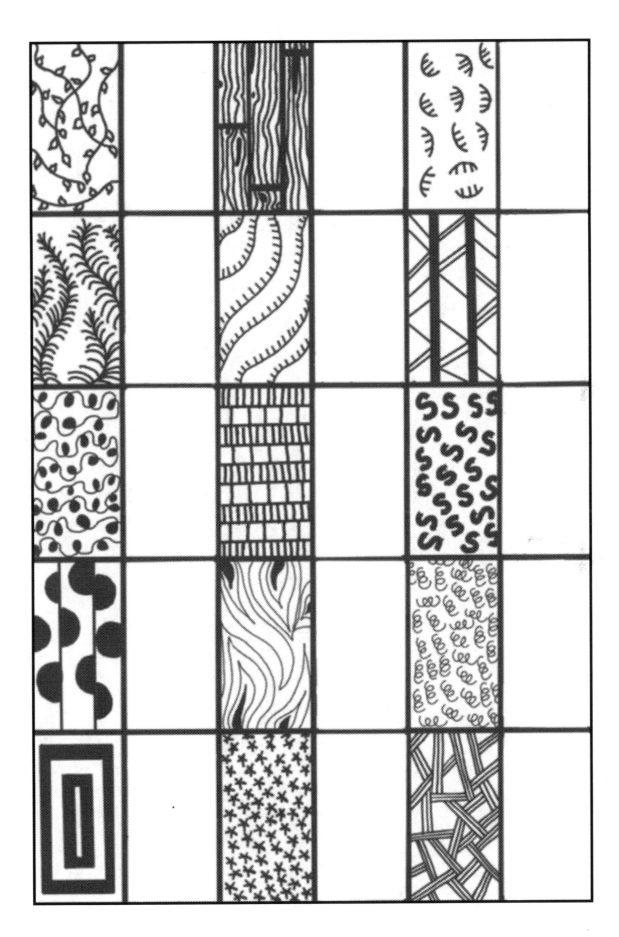

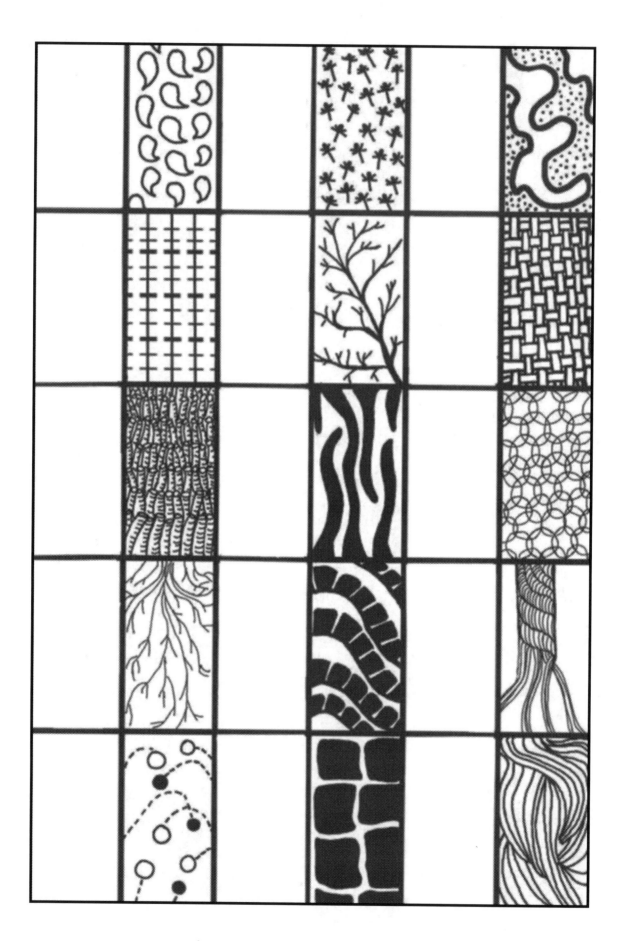

How many designs have stayed in your head? I would venture to say you have forgotten about half of them already. When I taught students to do pen designs, they did much better if they had guides right in front of them. I always had guide sheets for them to look at and choose from.

Before committing to pen, I highly recommend you make a few practice strokes on a scratch piece of paper. Even if you get familiar with certain strokes, you will find that this practice helps to warm up.

Exercise #3:

Now it is time to look around you. What new designs can you see in your house or outside? Are there variations of the ones I made? Fill up every box.

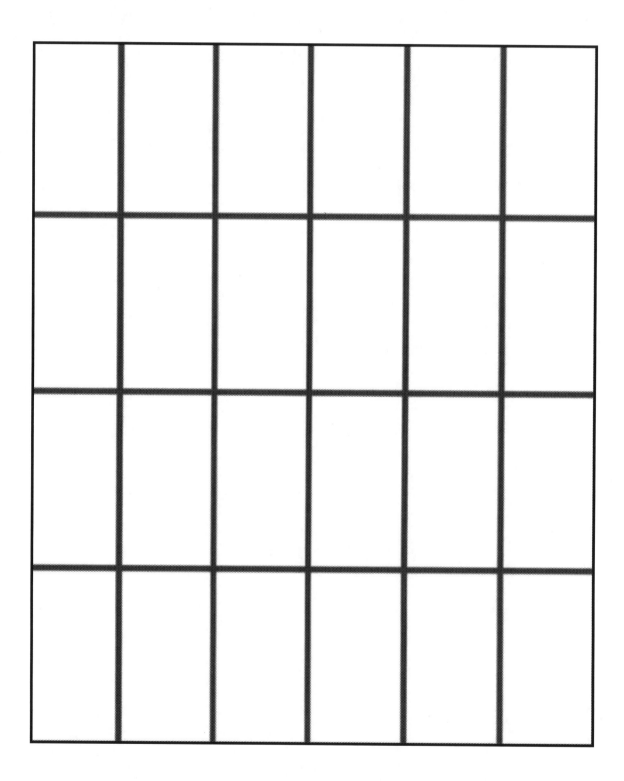

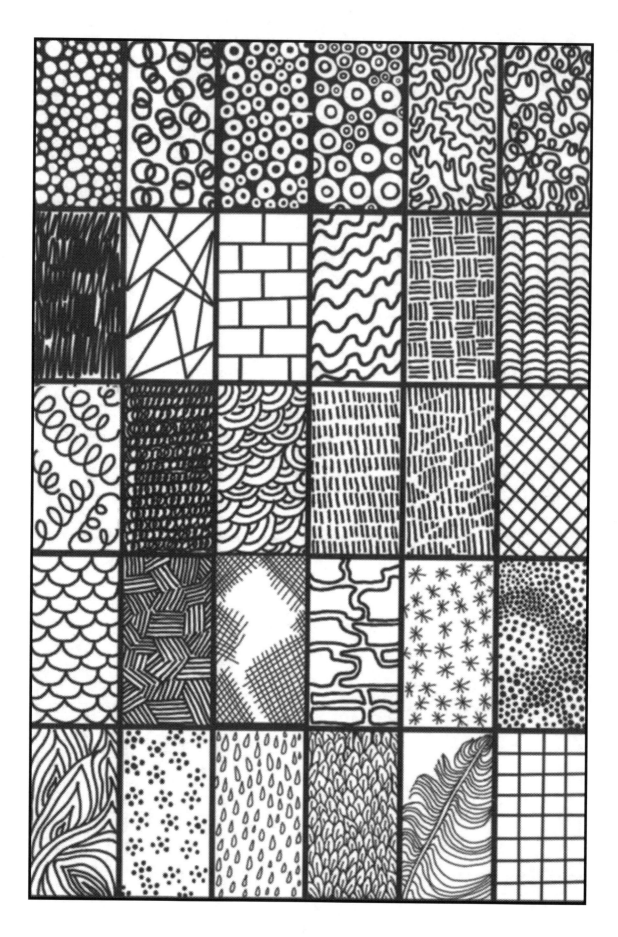

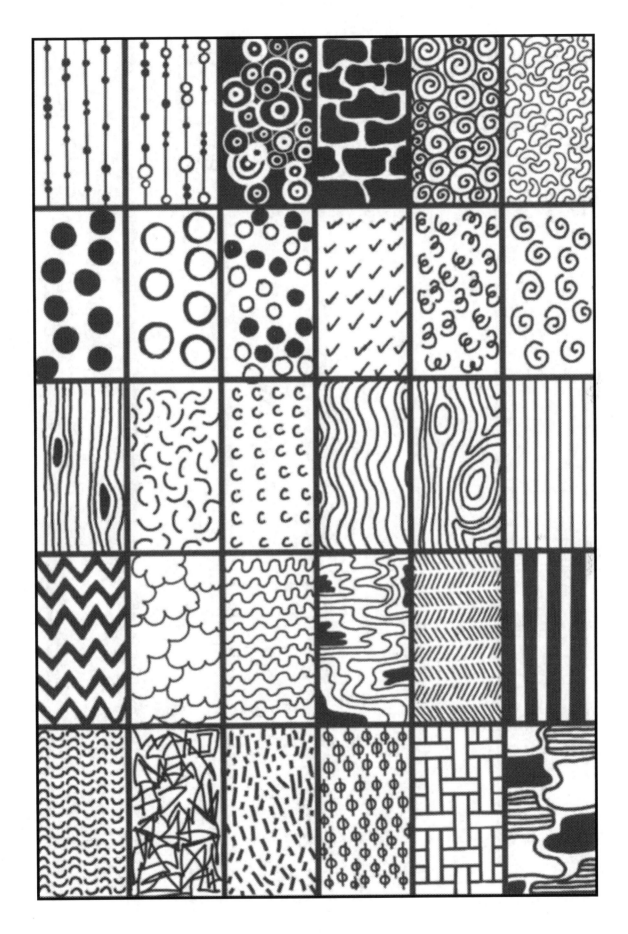

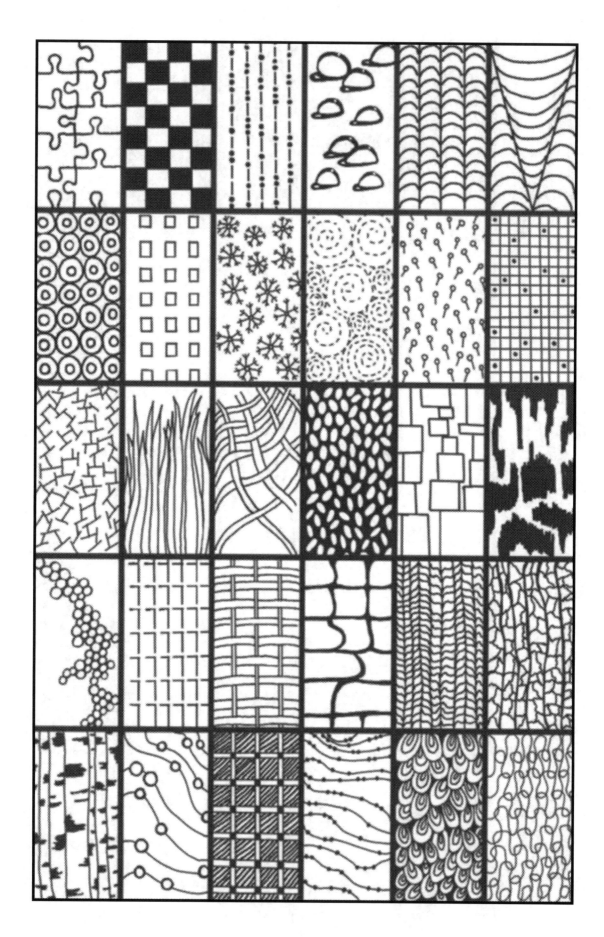

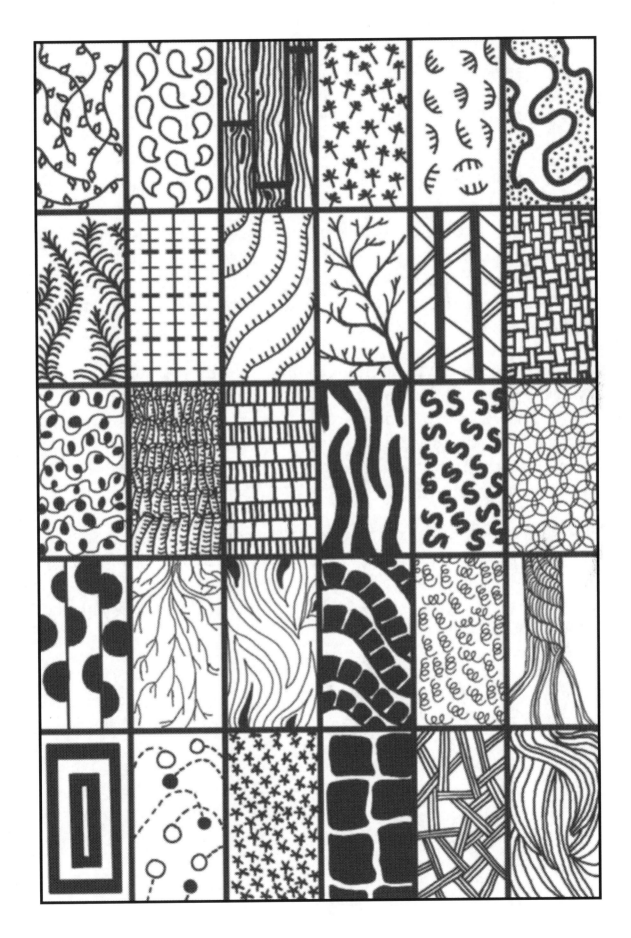

CHAPTER 2

USING THE DESIGNS

Jump in and fill the designs with any of my examples or ones that you created. In pictures, duplicating a pattern tends to please the eye and bring balance to your artwork. I chose to duplicate the dark designs. I was afraid the designs that were very open would cause the viewer to wander around the picture and not be able to engage. I put in the very dark area and still felt like it was lacking something. I repeated the same pattern. That decision brought better balance and focal points.

Plan carefully. Even if you are filling in a free design, you want to make it appealing in some way. Experiment. If all the darkness is on the top, it may seem top-heavy. If you have dark areas on the left or right without something to balance them, they could lead your viewer's eye right off the page. You must take a step back and look at your art. Ask yourself, "What is needed next?" Do this throughout the process.

This is your art, and I encourage you not to compare yourself to others. However, on this simple assignment, it does not hurt to have a few people do it and see which drawings catch your eye. Then ask yourself, "Why does that one appeal to me?" On the other hand, find what seems to throw you off or send you into a yawn.

There are times when you may want to work in hidden faces or objects. Pencil them in ahead of time. Keep it simple! When you work, choose designs, light with dark around or dark with light around. When you are finished, the design will pop.

Exercise #1 - Freestyle Design

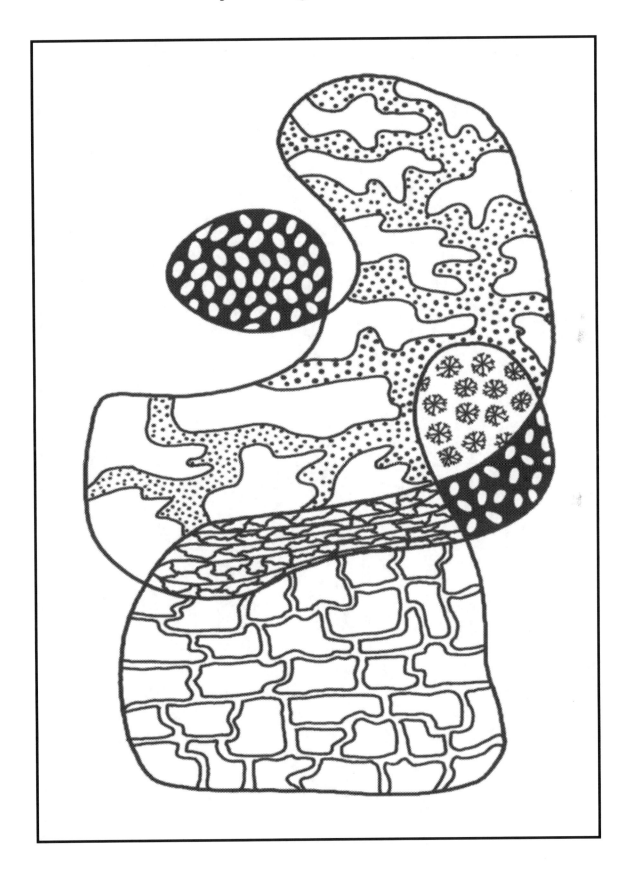

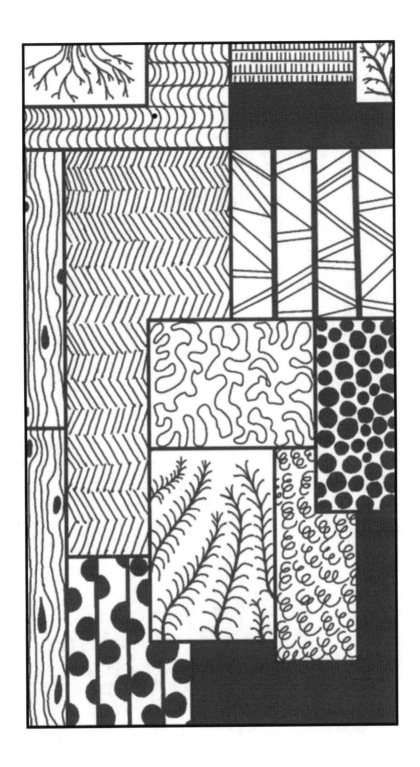

Exercise #2: Geometric Shapes

In the previous exercise, you filled in scribbled and rectangular shapes. This time you will choose objects to trace. I like to touch the edges to make a cohesive feel to the picture. Duplicating patterns by grouping and being selective of the designs you choose makes for a more appealing picture.

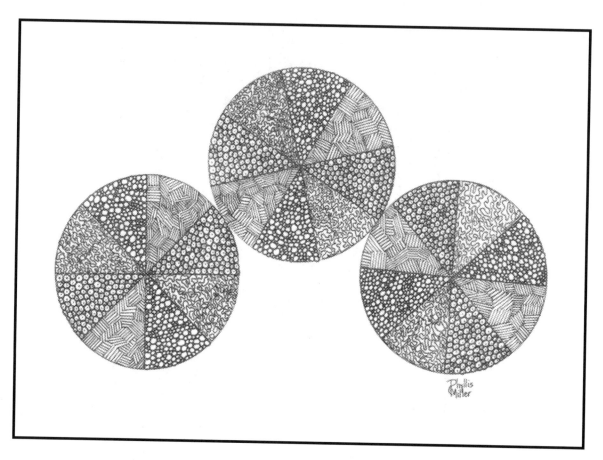

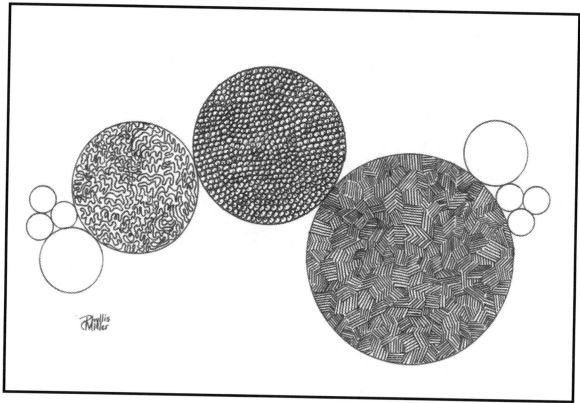

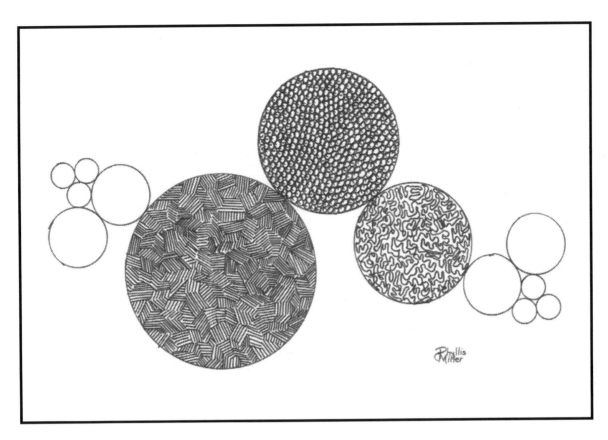

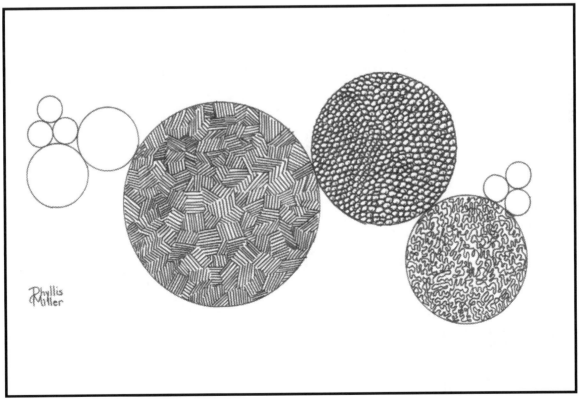

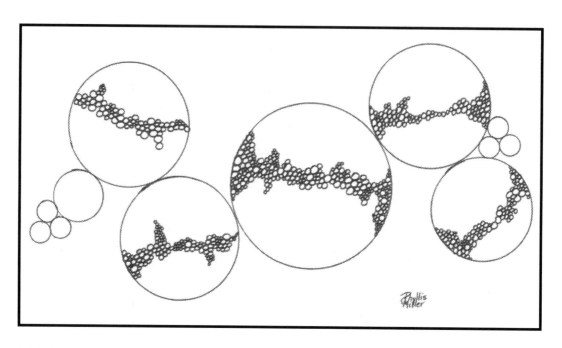

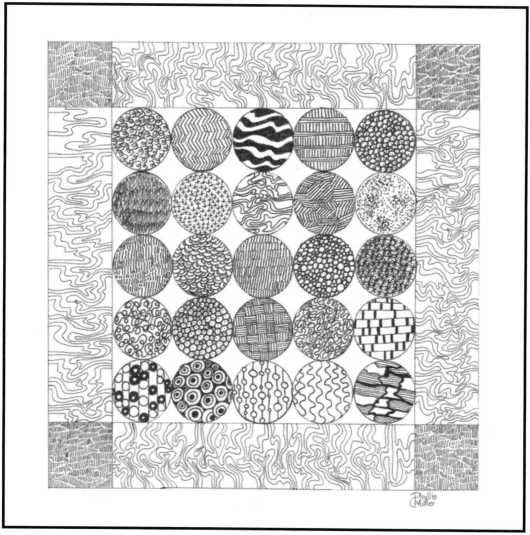

Use a mixture of rectangles, squares, and circles. You can complete a piece of art that is ready to frame.

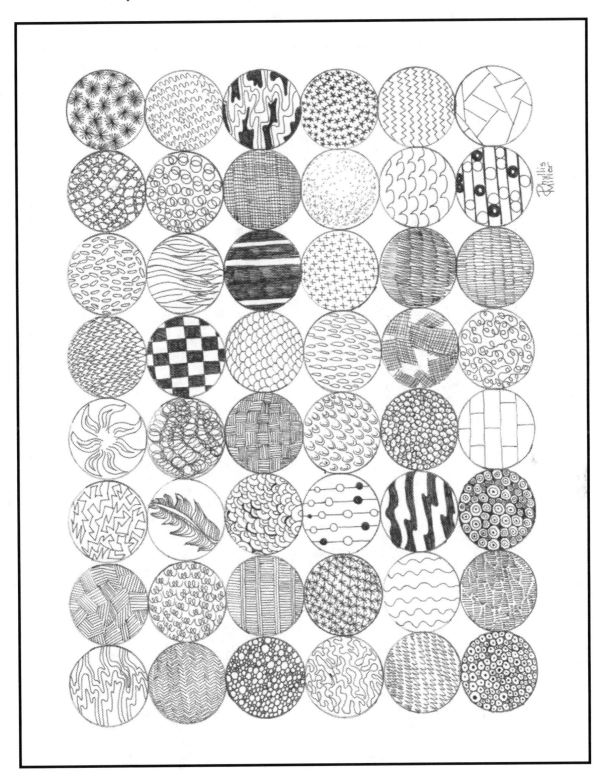

Look carefully at the scribble design on the right side of the artwork below. I concealed the words "Seize the Day." I used a ruler to make marks in pencil before committing to pen for the main lines.

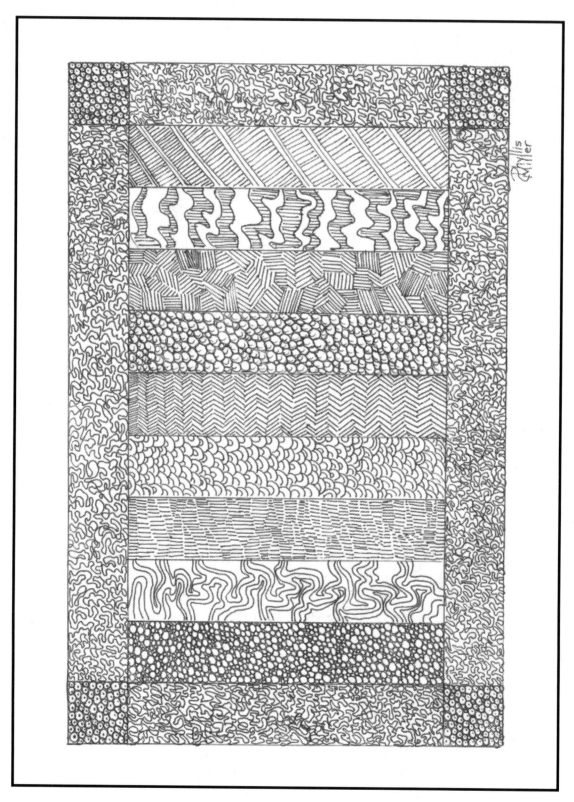

Exercise #3: Weaving & Shapes

Break from geometric shapes. These are basic, interwoven lines. I drew simple wavy lines one direction and then the other with a pencil. Then I drew up to the line, left a small gap, and continued to the next line. You have an example in this book. Warning! I did not get this right the first time. It took a few attempts.

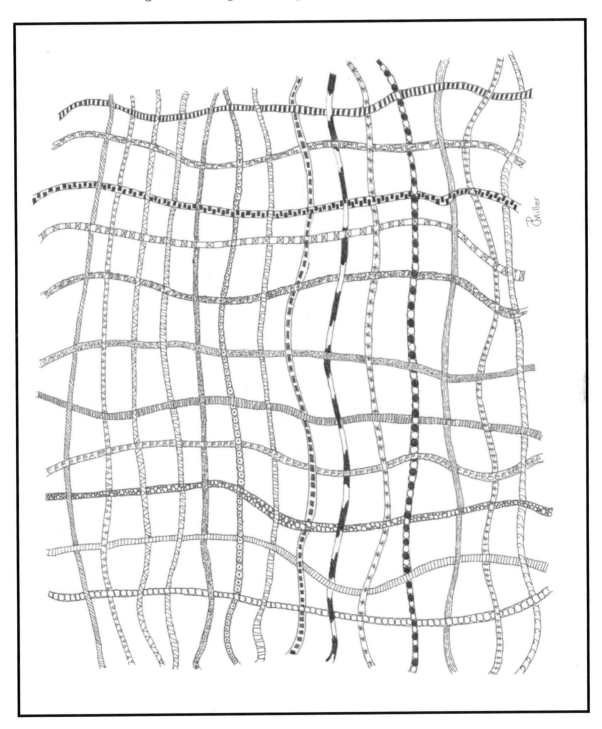

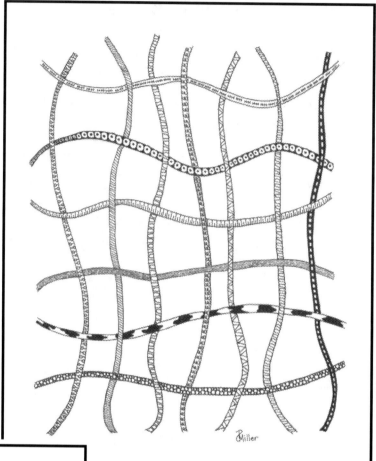

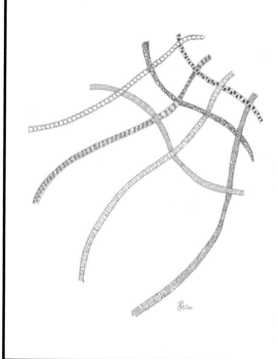

Breaking away from free design, geometric shapes, and woven lines, I used cardboard shapes I found at a local thrift shop—a random piece of garbage that most people would have thrown away. Luckily, someone put a price sticker on it, and it became my inspiration.

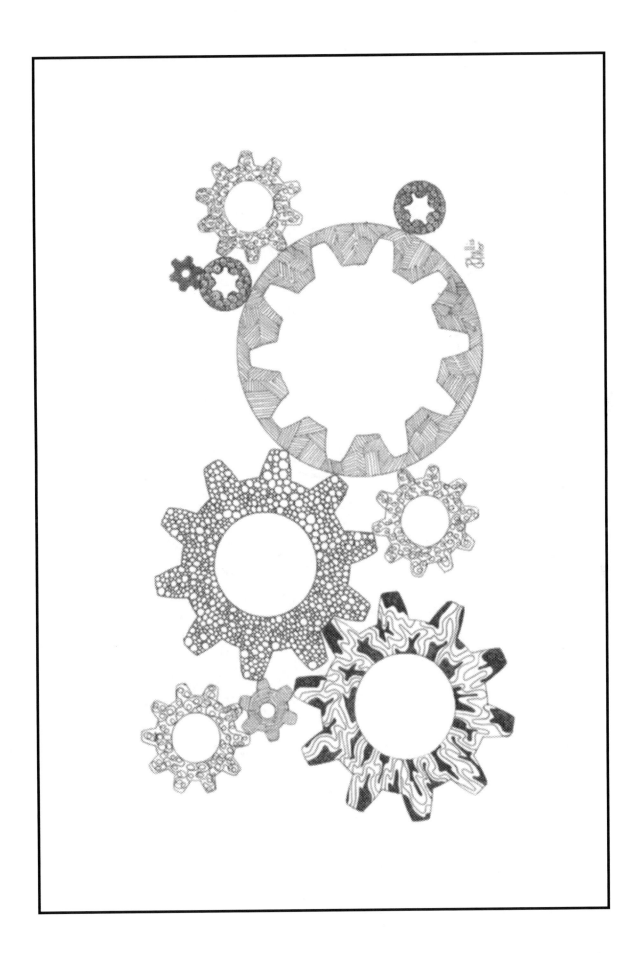

These grass blades were too plain by themselves. Adding textures with different patterns makes them come alive.

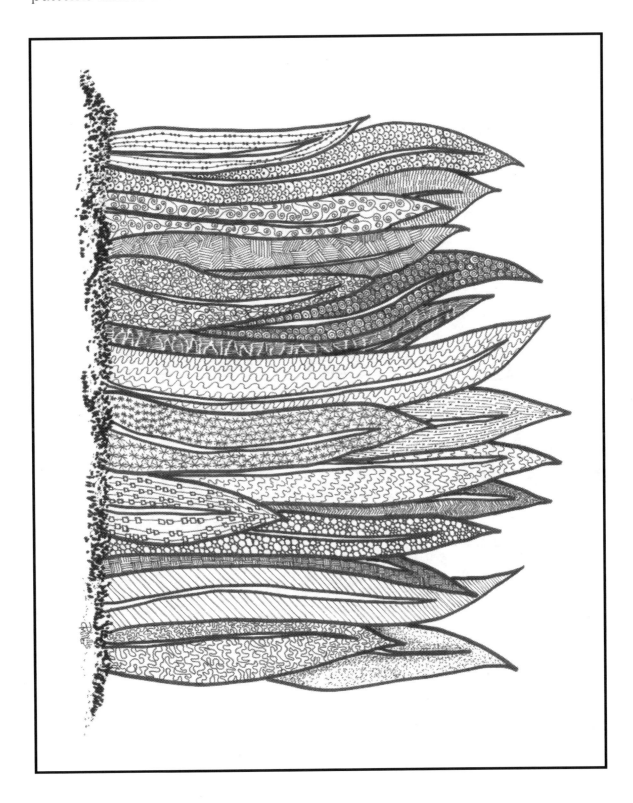

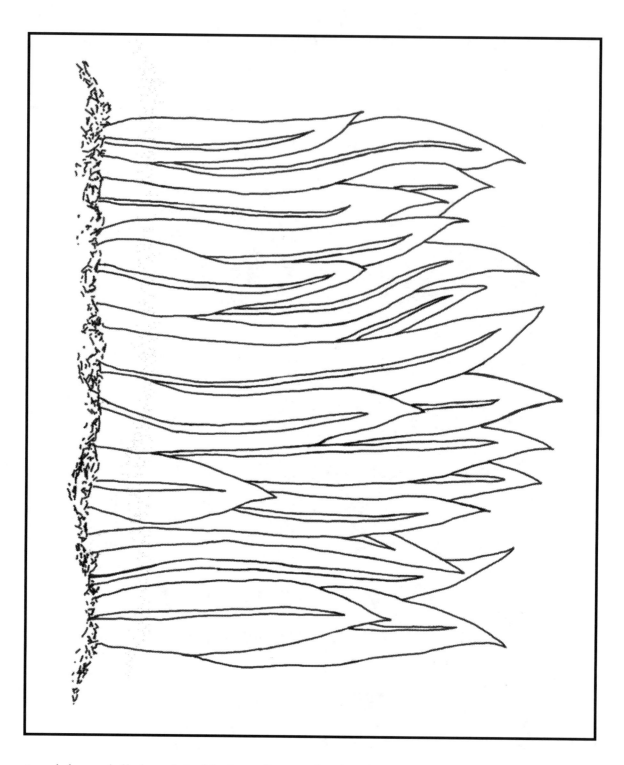

Look how dull the plain blades of grass look. Fill each blade with patterns. Fill in the center of each blade with black or patterns for different looks.

C H A P T E R 3

USING SIMPLE OUTLINES

Simple outlined pictures are a gold mine for practicing your pen designs. Basic coloring books provide black outlined pictures for practice. Just beware … they are not acid free and will deteriorate and discolor over time. If you have a finished product, you wish to frame or archive, use an acid-free paper. Archival paper is also a preference. Use an art pen that is both waterproof and permanent.

Here are three penguins for inspiring your own ideas. Choose designs that appeal to you. Notice that each penguin uses three designs. I thought it was a bit boring. I changed it to four designs and split it where I thought a separation of patterns would look better.

Themes can add to the finished product. I wanted the first penguin to look like living things. I chose a fern, dandelion seeds, and overlapping leaves.

The second penguin included more designs you might find around the house: a torn screen, a basket, a scribble pattern that resembled Christmas lights, and plain scribbles to carry over the flow of the Christmas lights.

The third and final penguin has child-like designs: bouncing balls, suckers, gumballs or pebbles, and scribble-like springs.

Exercise #1: Penguin and Lizard

Study the three penguins. Which one catches your attention more than the others? Why? I cannot say I have a favorite. Each has its own personality. Copy the outline of the penguin or draw right in the book. Choose designs you plan to use. Choose where to put the design before committing with ink.

A lizard comes crawling across the next page. There are only two pattern boxes on this first lizard, and it is a bit dull. The second lizard also has two patterns,

but there is a difference. I did not stay 100 percent like the sample pattern. I varied the size of the bubbles to break the monotony with the middle section. As I was thinking of a lizard my son once had, I thought of it shedding its skin. I started the swirled balls at the head and began to wonder if I could make it look like shedding skin if I left areas of white.

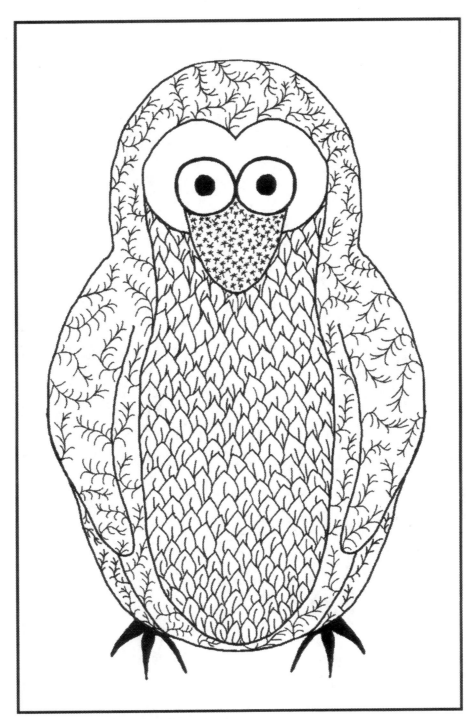

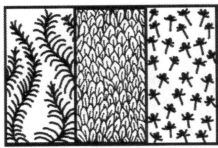

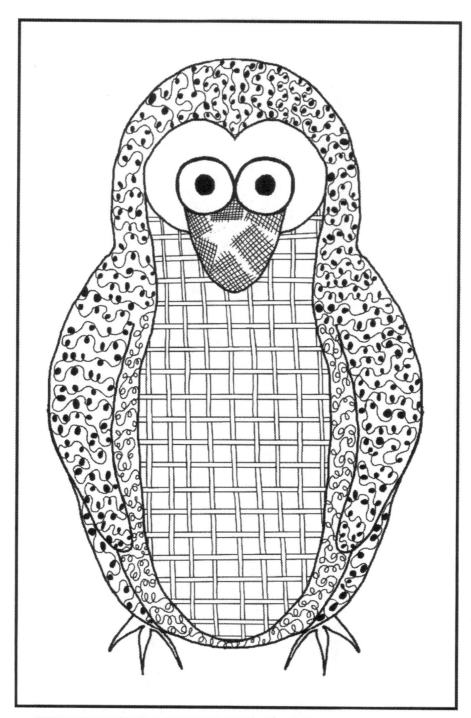

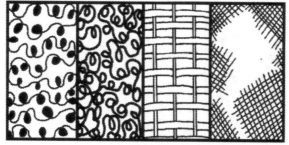

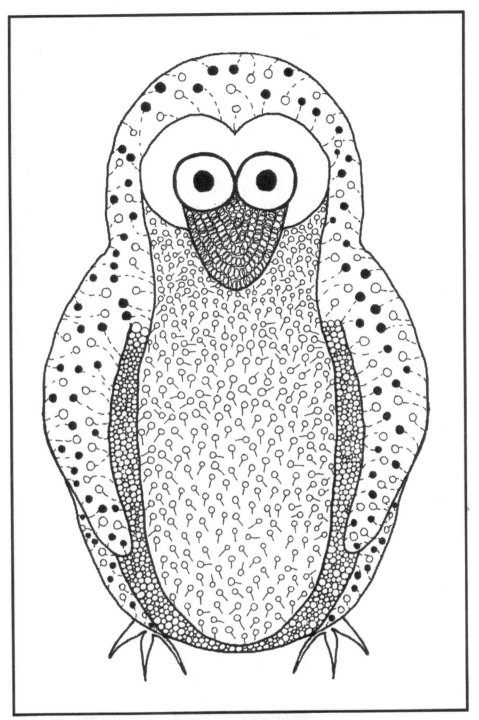

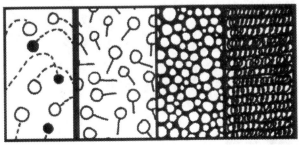

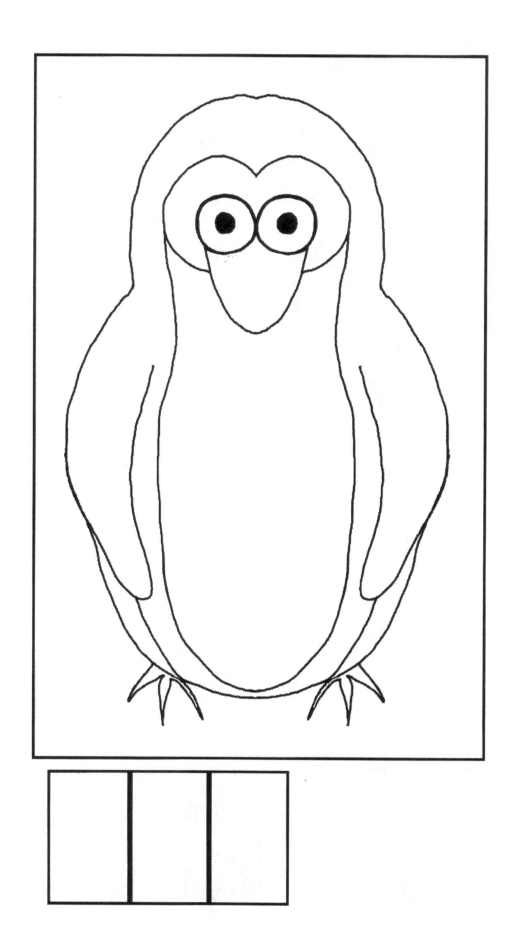

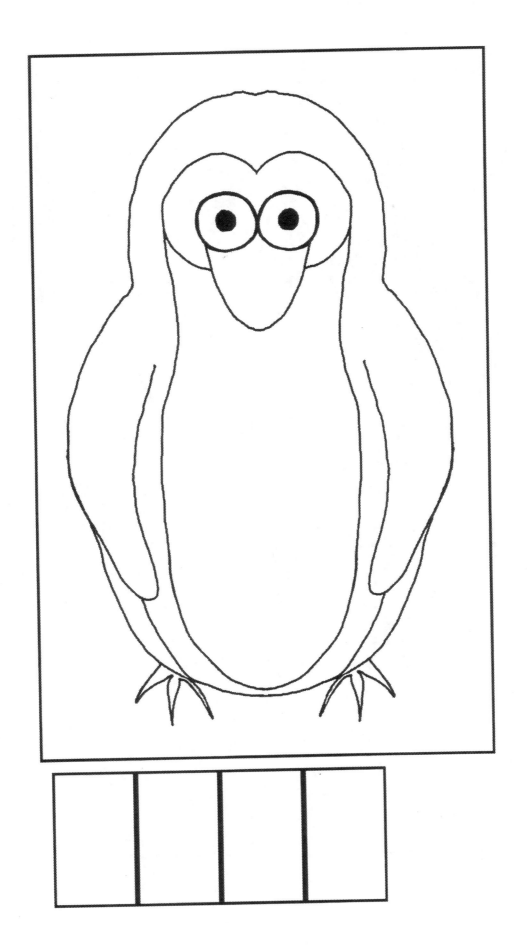

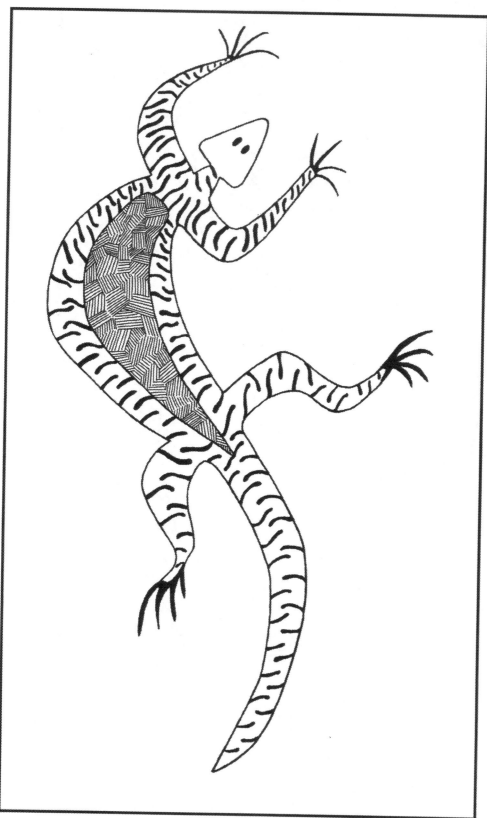

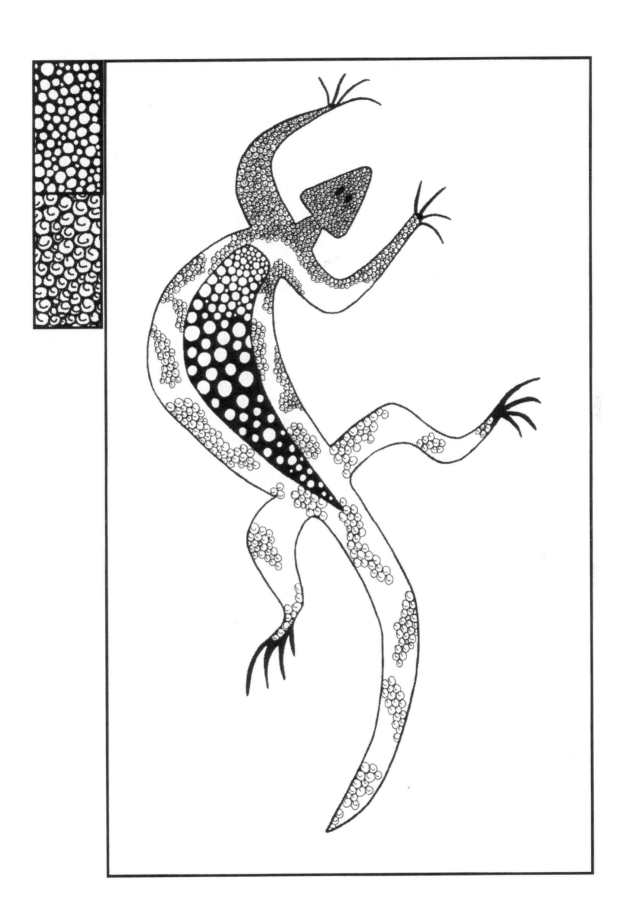

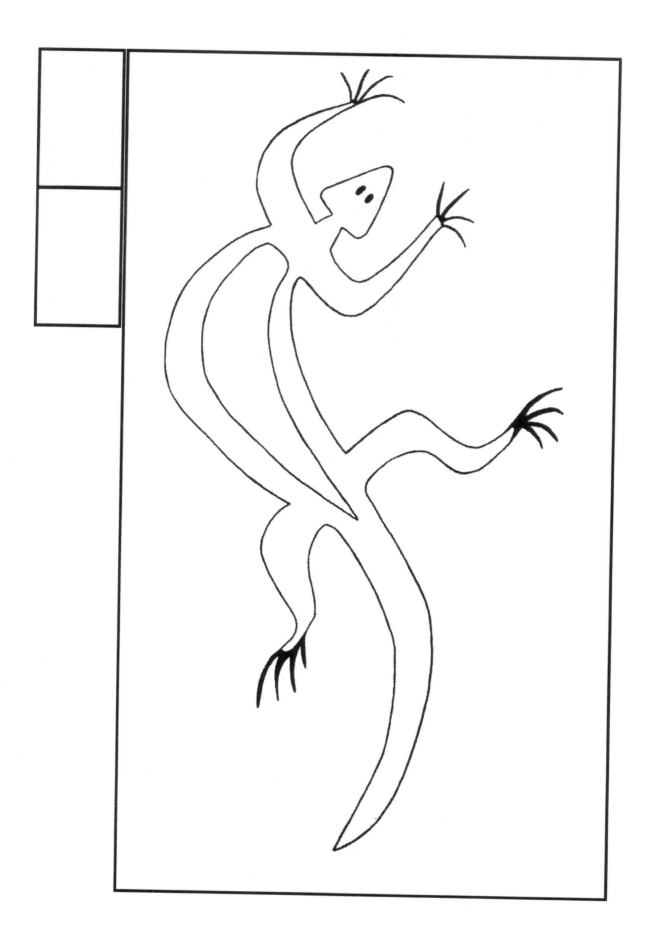

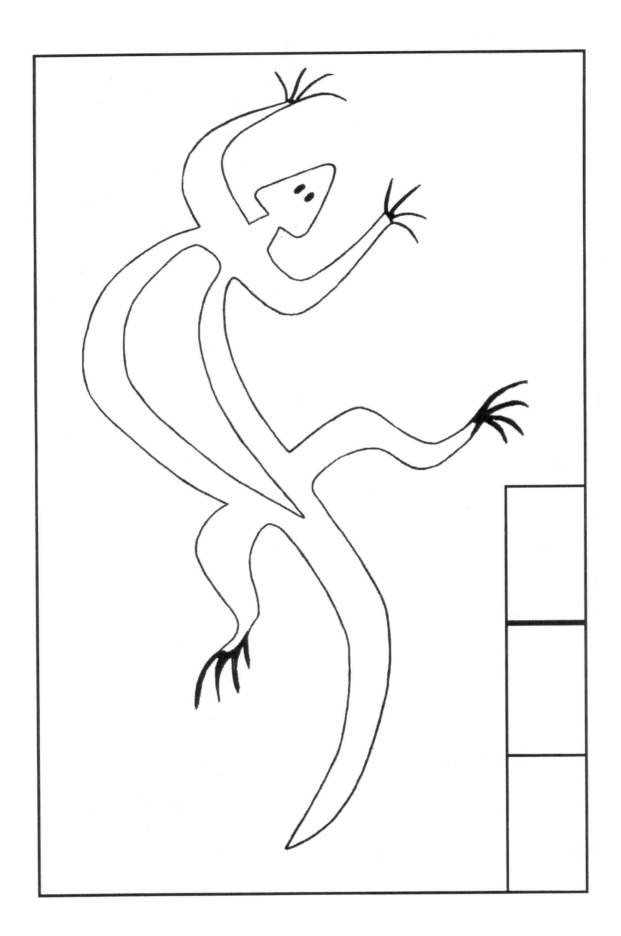

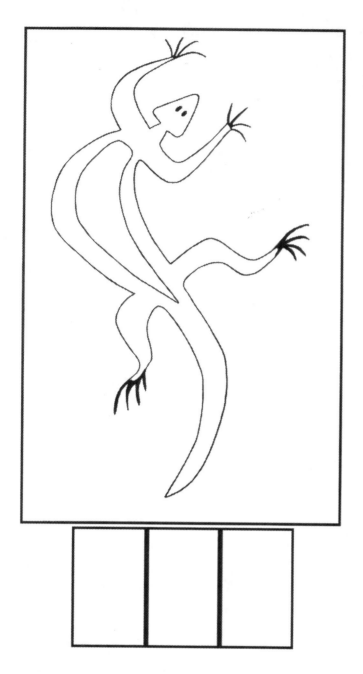

I never used three designs in any of the lizards. Can you think of a way to incorporate a third pattern?

Decorate the small lizard. Carefully choose what would fit into the small areas. Use two or three pen designs. You could also use a color pen for part of the skin. Using darker patterns will enhance the shaded areas.

Exercise #2: Candy Jars

The next pages feature candy jars. Make them all the same or change each one. This book has focused on the basic black pen, but you may want to use different colors of markers or gel pens. Put a pattern into each candy. Try all the same color.

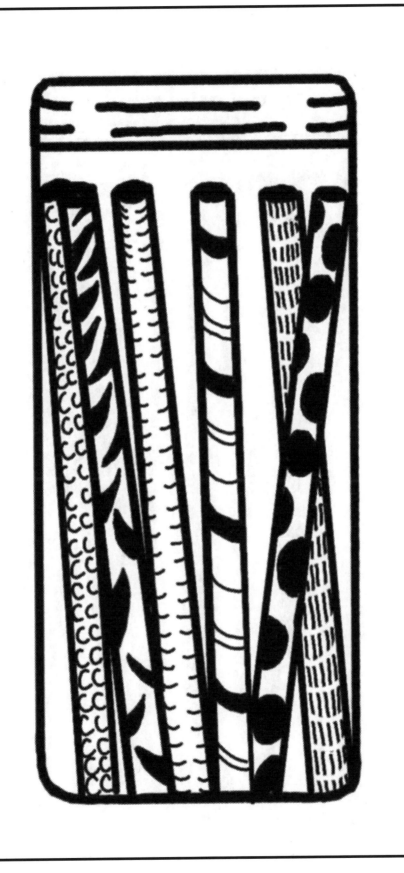

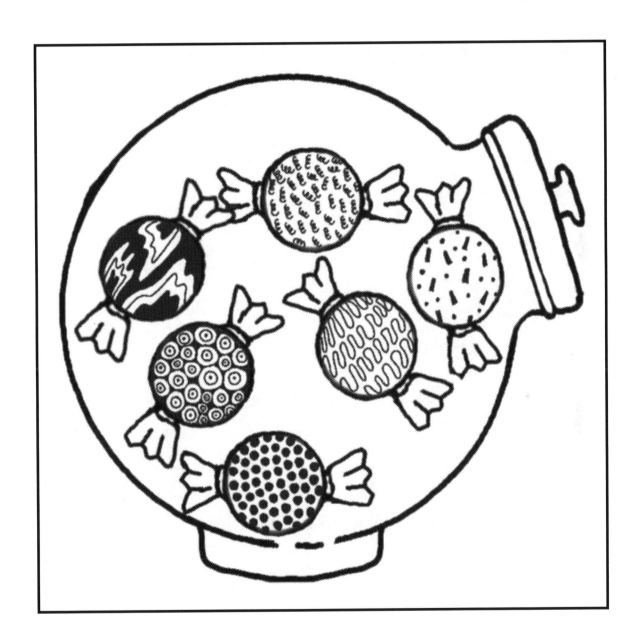

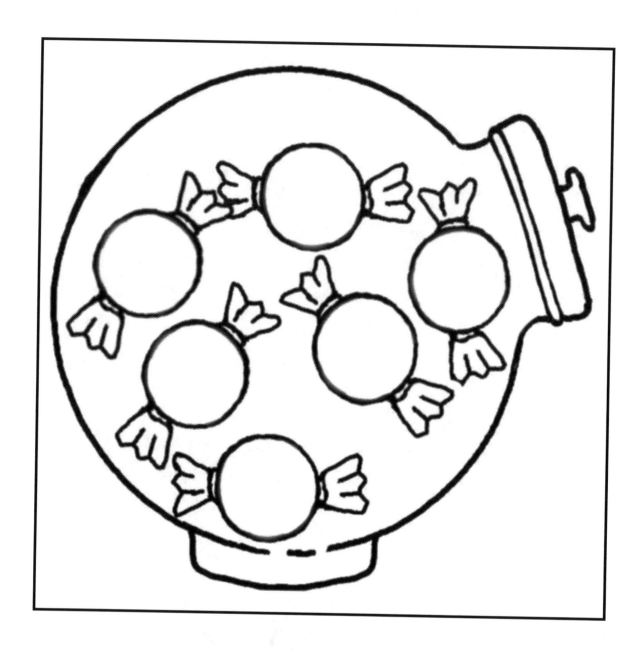

Exercise #3: Using Textures in Art Outlines

The texture used on a black outline gives an ordinary picture some flare. I used bubbles on the shark. The shark does not look as threatening filled with bubbles. On my original picture, I used turquoise and sky-blue acrylic paint to dip varying sizes of round circles around the shark. By using two simple acrylic colors, it made it look like the shark was swimming in water. I changed the circles to black because the bubbles in gray were not appealing. Try one of your own in the box below using bubbles.

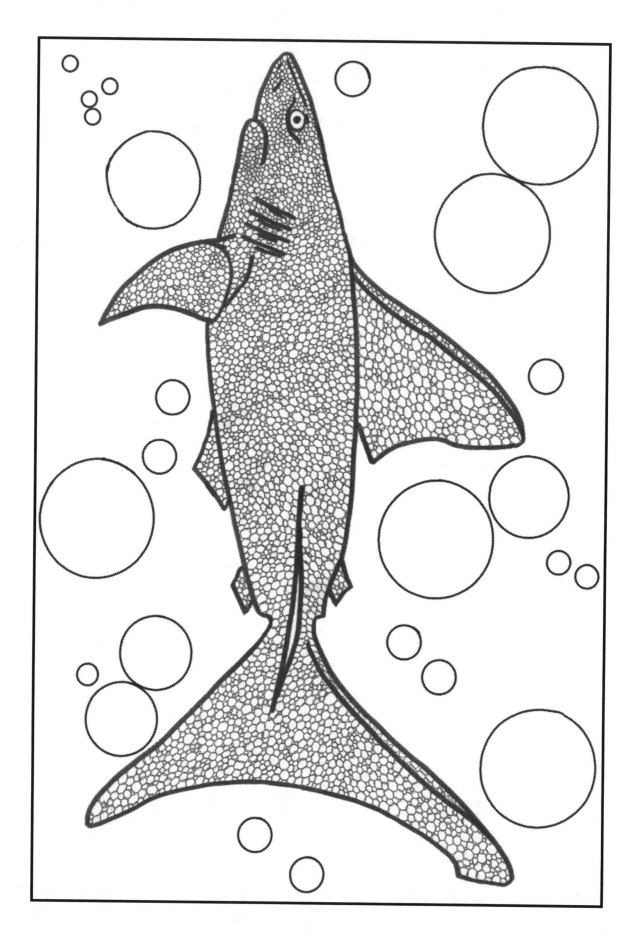

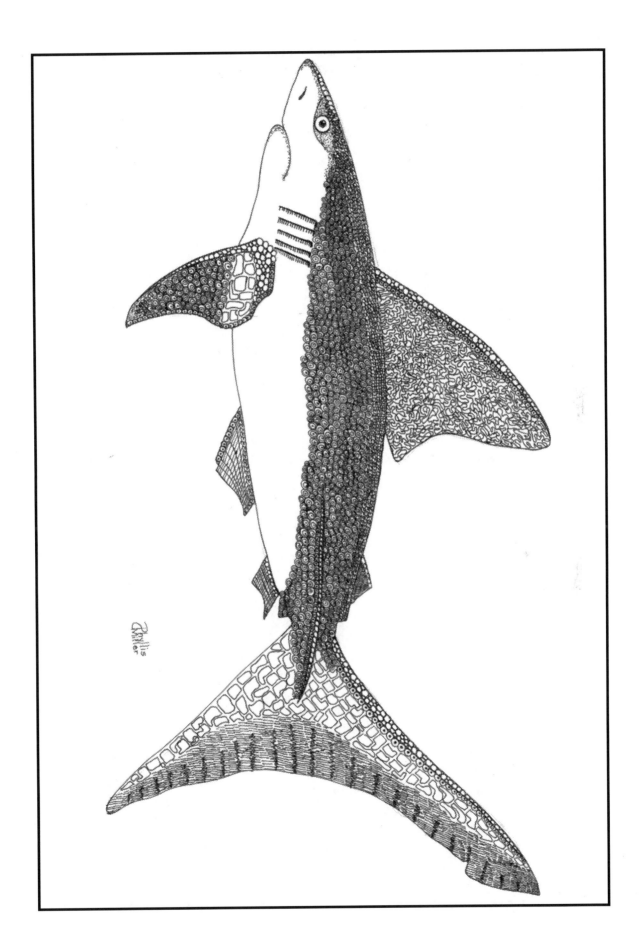

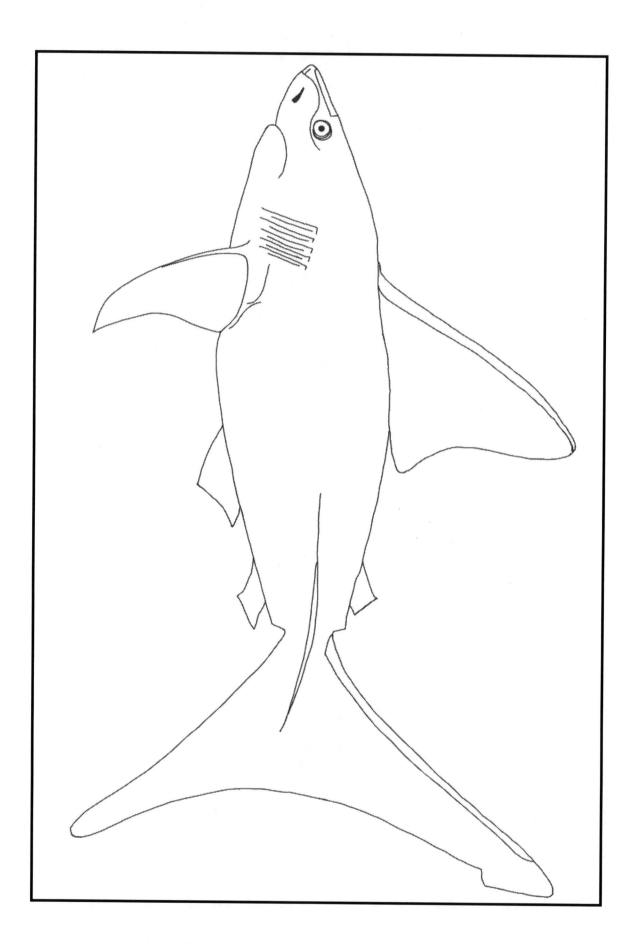

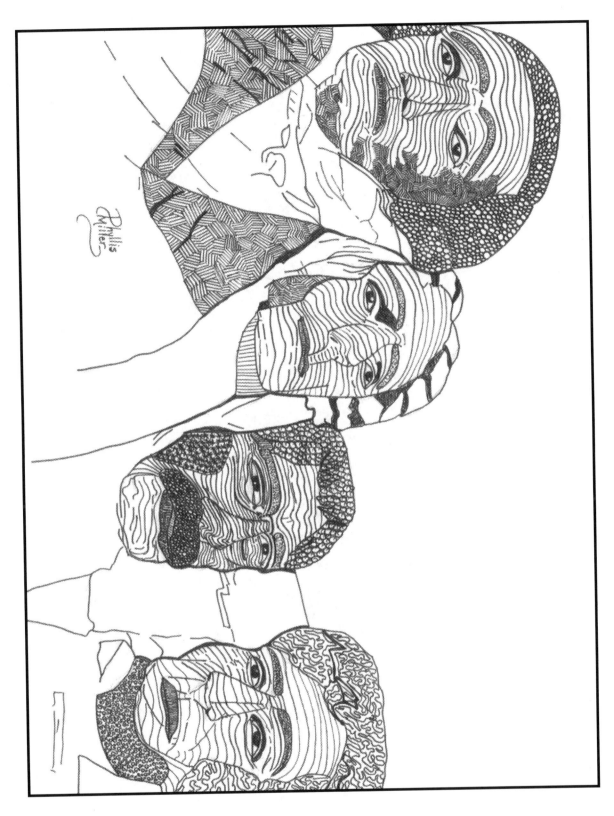

Mt. Rushmore was tricky because of the facial details that I did not want to lose. I chose simple lines that took on a wood appearance to make it easier to follow the contours of the face.

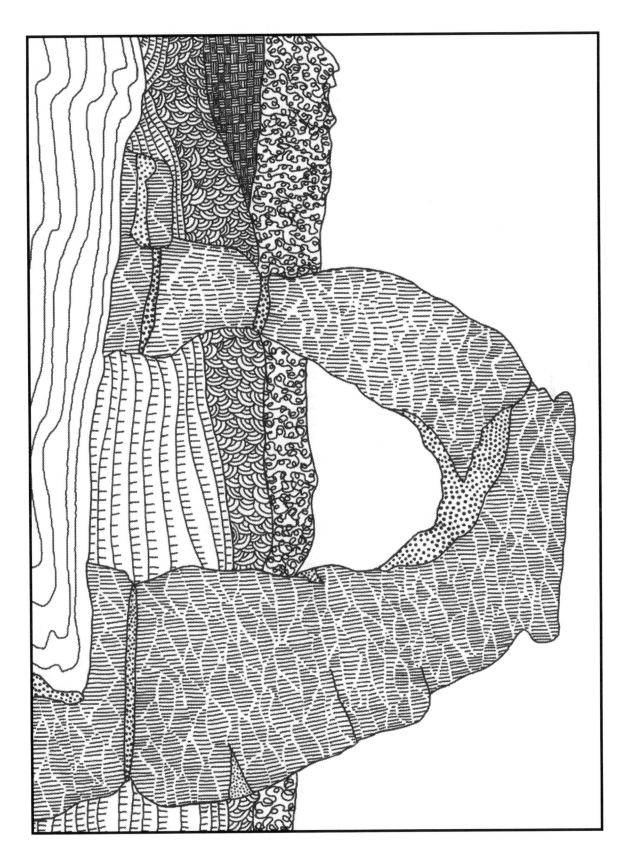

Delicate Arch is one of my favorite arches in Arches National Park. Look at the variations and come up with your own.

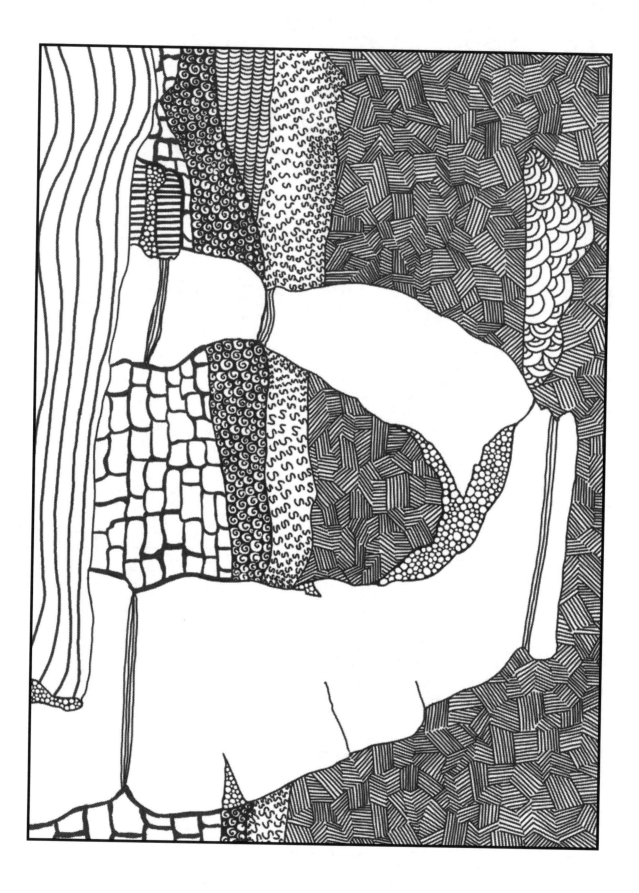

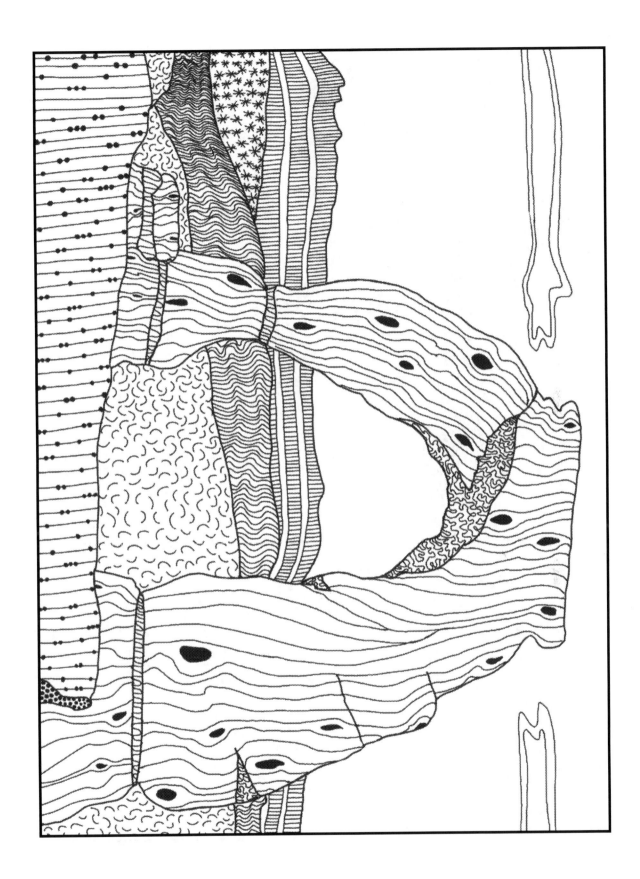

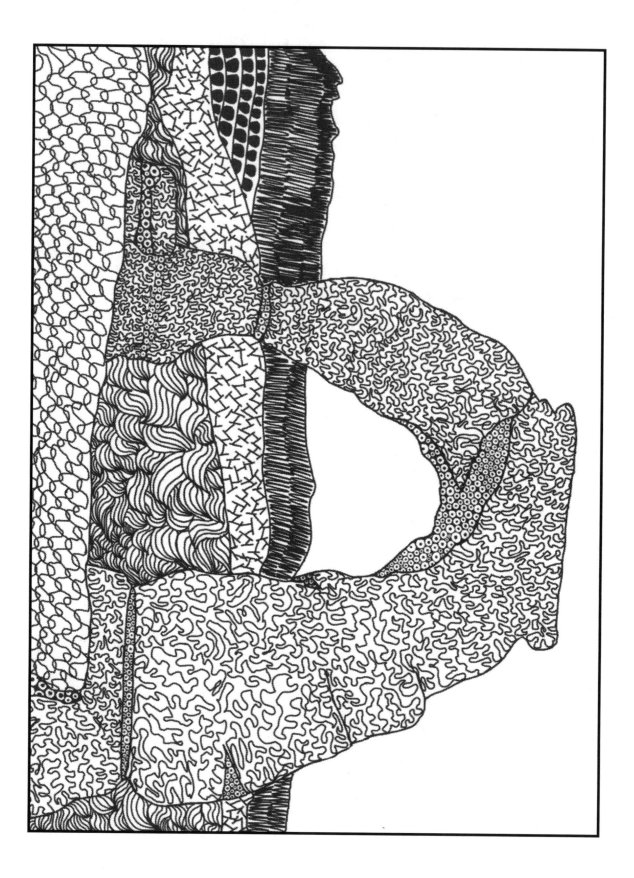

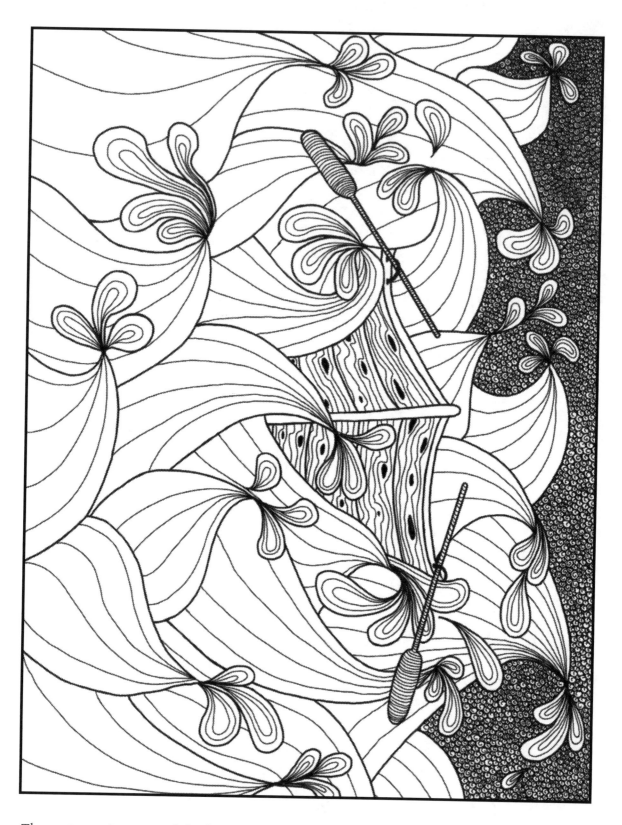

These two pictures of the boat tossed in the waves are vastly different by using different pen designs. Try it more than once.

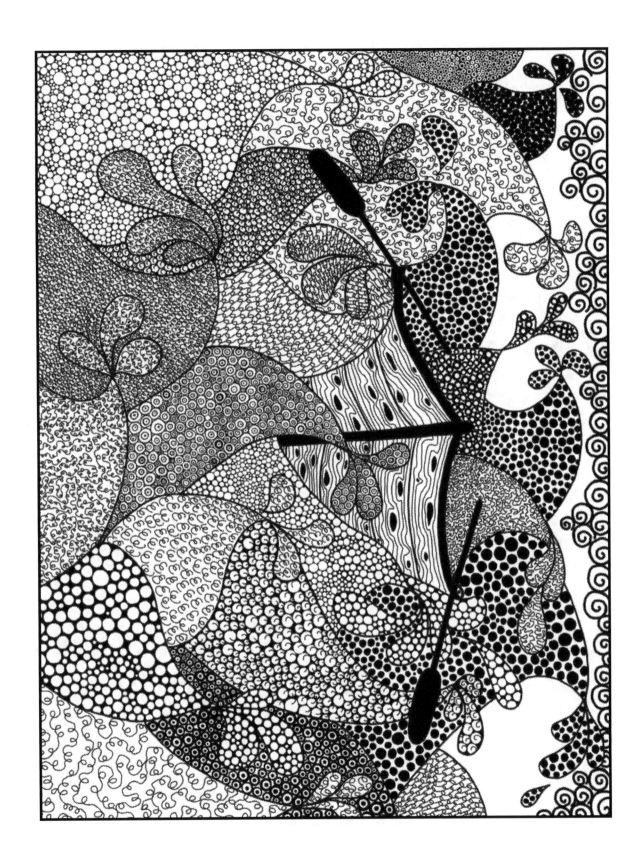

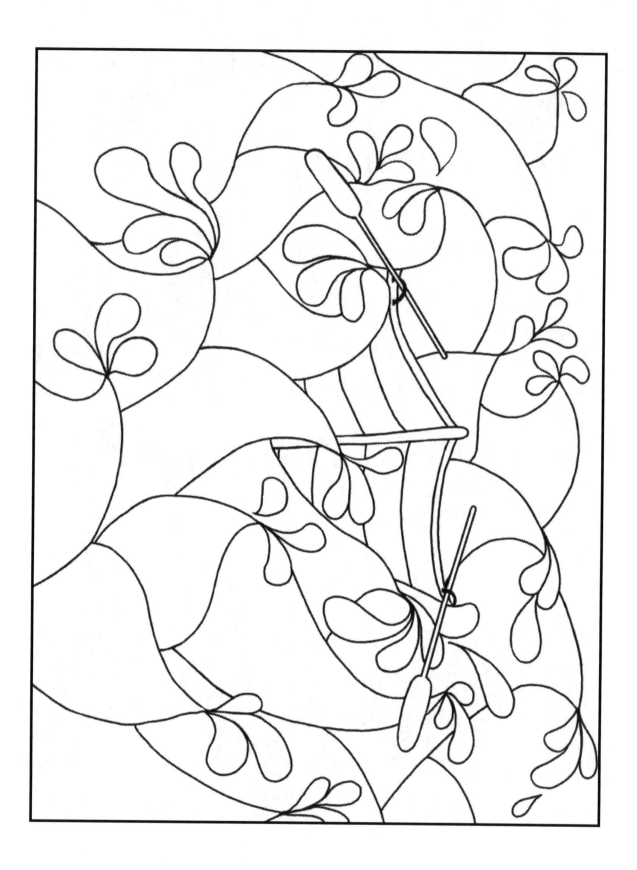

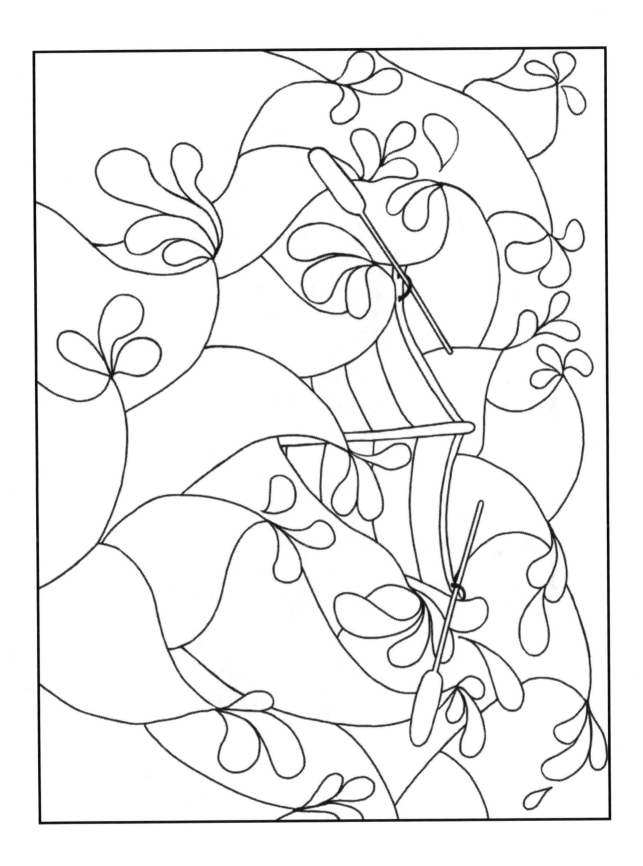

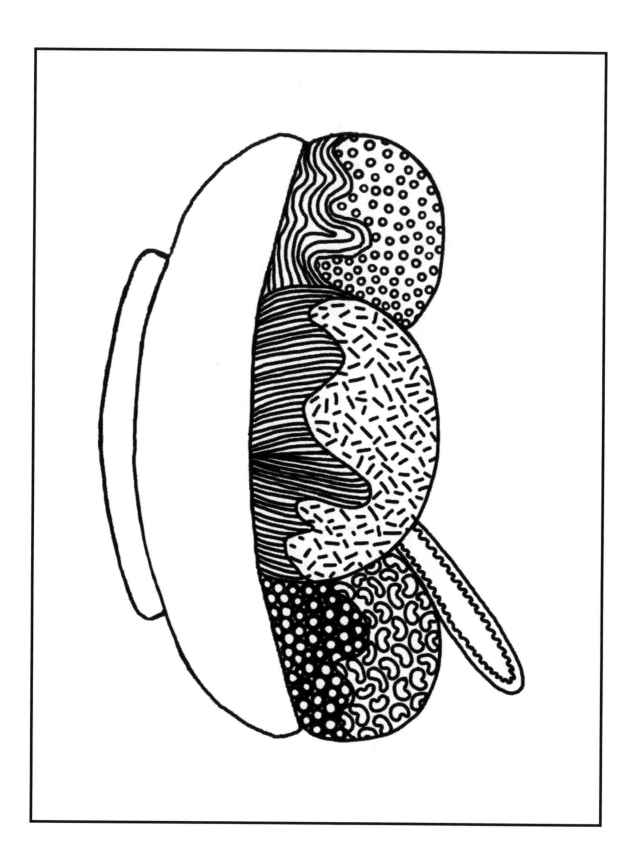

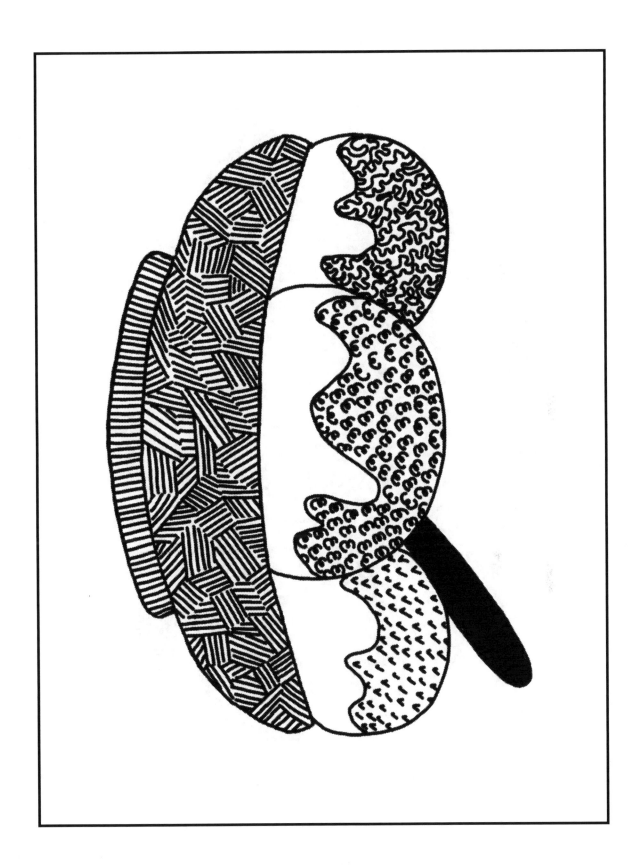

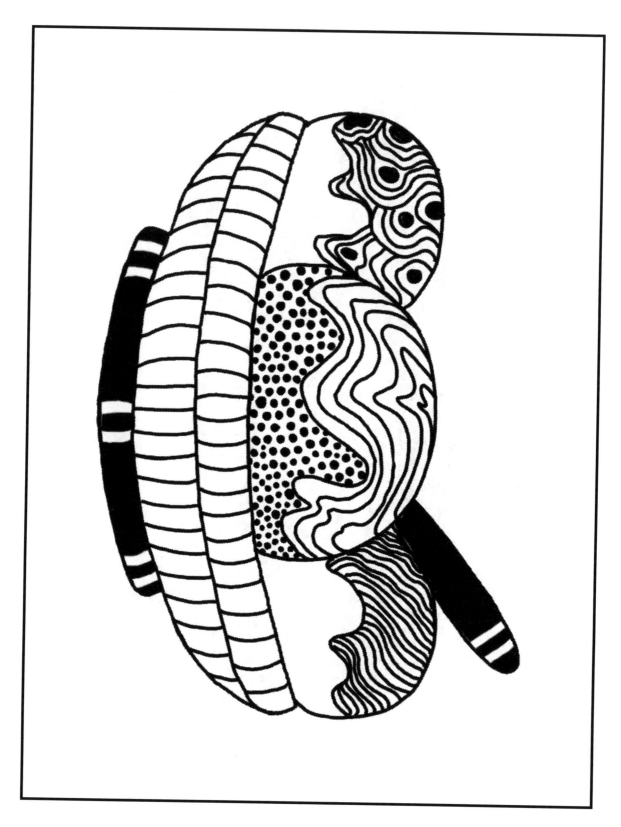

Sundaes are simple to do. Add a banana if you would like. Think of the different values that each flavor and topping has and vary the pen designs. It is best if the same value is not close together.

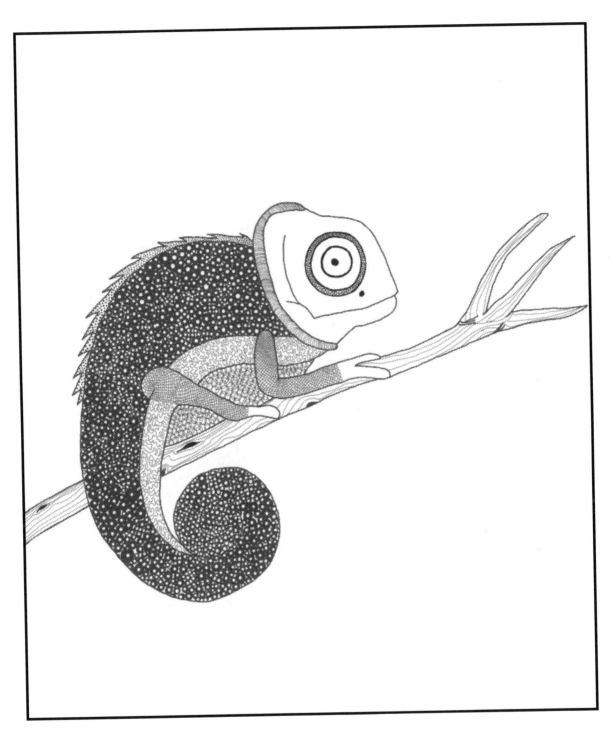

I did not fill in the face of the first chameleon. In pictures, having spaces that are pure white or pure black can add a punch to the overall effect. It can also balance the positive and negative space. I filled in the second chameleon's face so you could see the difference between the two. Then I went on to fill in the space around the chameleon to show what you could do with the background. Try a background of your choice with the chameleon or tiger.

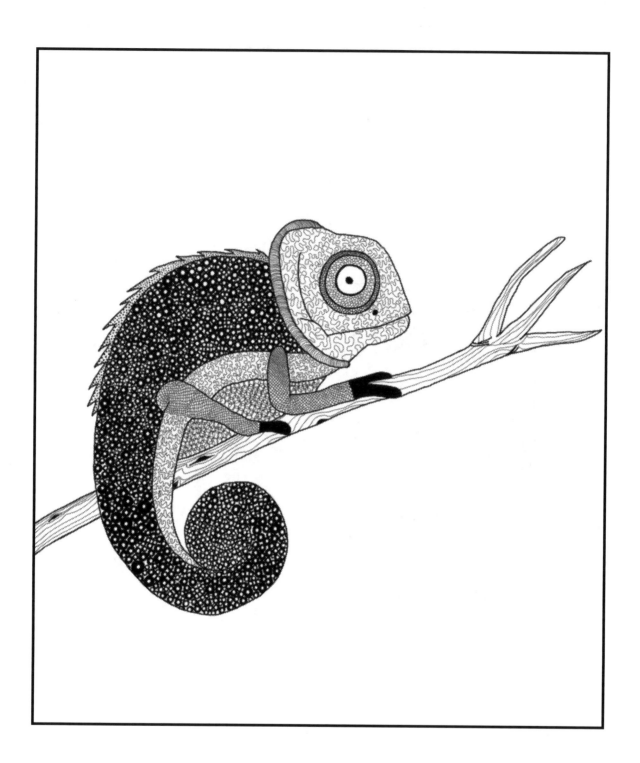

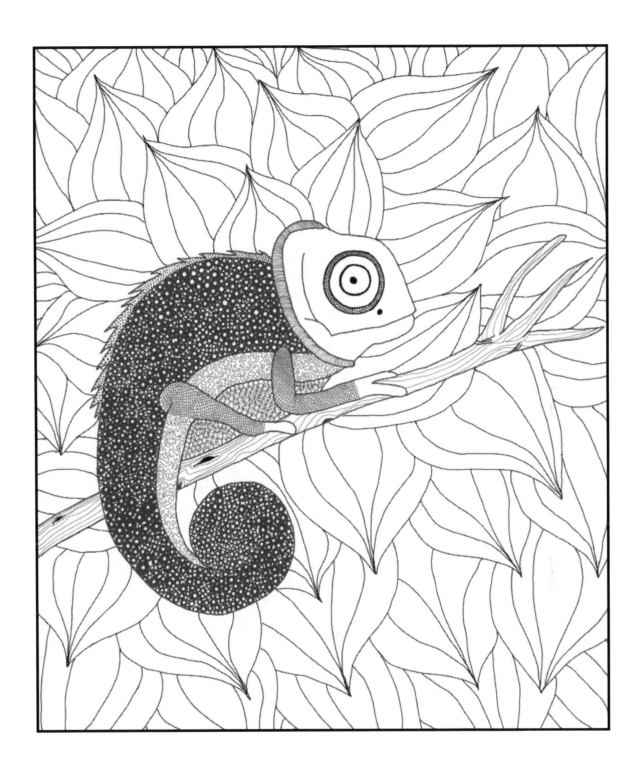

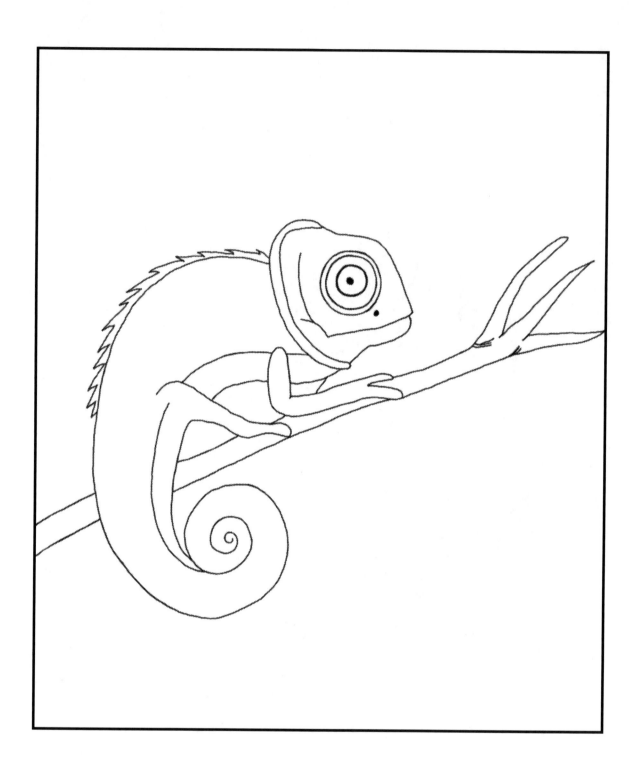

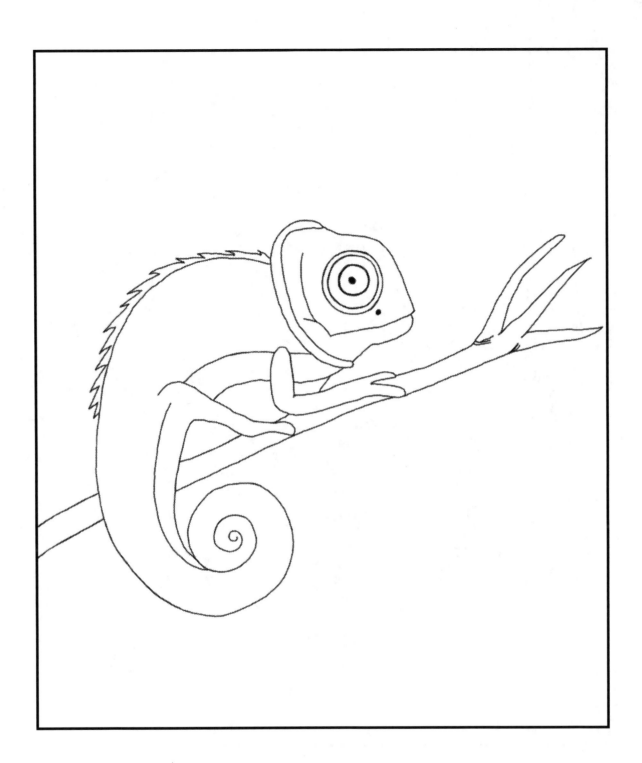

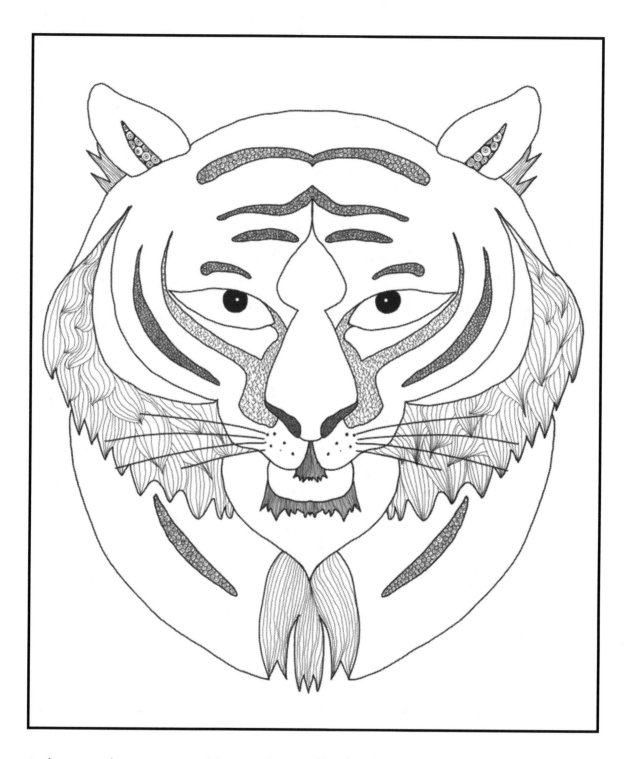

I chose to leave areas white to show off other lines in the face. I wanted the mane to show up and the details around the nose. I chose to fill in the second lion's face and draw the focus to the eyes.

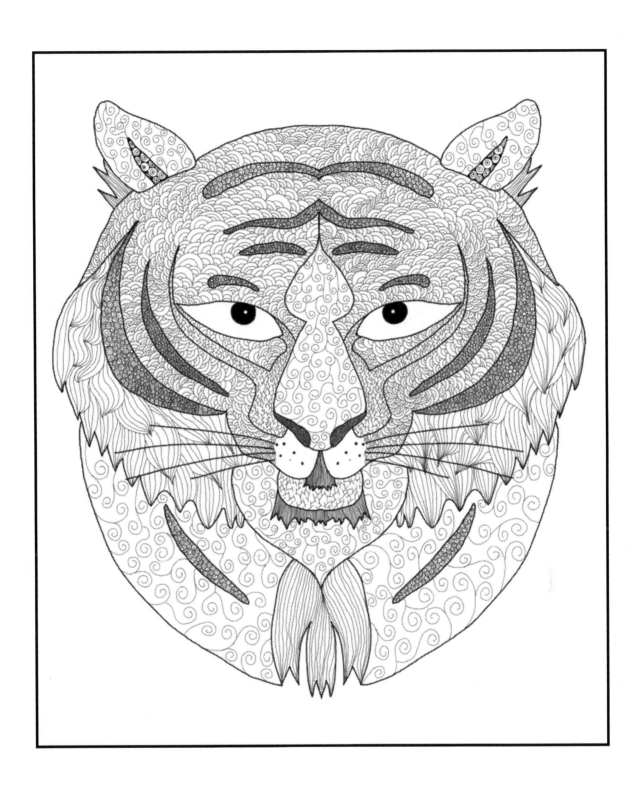

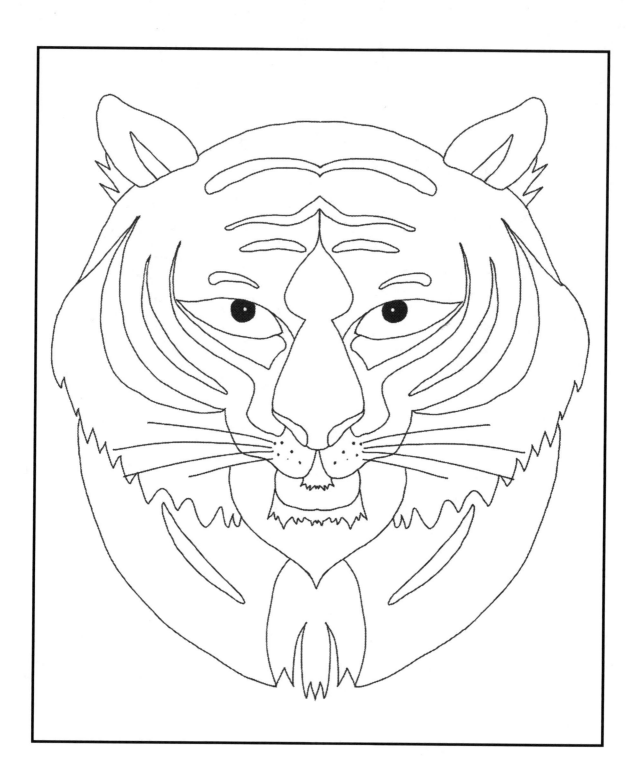

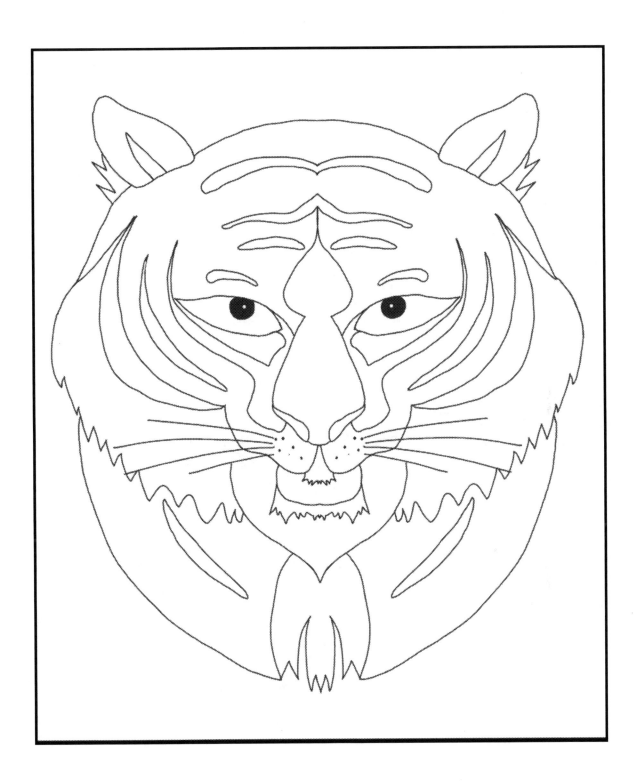

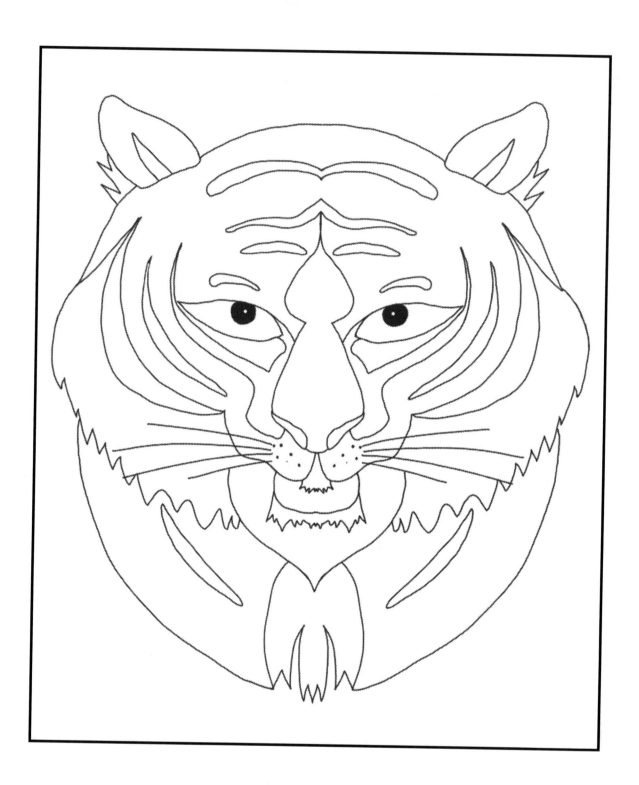

CONCLUSION

The steps are easy. Find a simple outline or draw one. Think about your light and dark areas. Choose designs that will work in each area.

Use the same outline, more than once, and see how the choice of pen designs changes the feel of each finished picture.

I have included a bank of pen designs. Many of them came from my surroundings. Add more designs of your own. I have a granddaughter, Sydney, who was enthralled with the design pages. I gave her a blank page of rectangles to fill in her own designs. She spent three days filling in the rectangles, stretching to find ideas to fill in all of the boxes. If a five year old can do it, than anyone can.

Have fun!

ABOUT THE AUTHOR

Phyllis P. Miller is passionate about guiding people to release their inner artistic talents. She earned a master's degree in Elementary Education and taught school for nineteen years. Phyllis and her husband have five grown children, each with unique talents, and live in Southern Utah.